Indian Basketry Artists of the Southwest

The writing of this book was sponsored by a gift from
Lore Thorpe to the Indian Arts Fund at the School of American
Research. Publication of the Contemporary Indian Artists Series
is made possible by generous funding from the
Katrin H. Lamon Endowment and an anonymous donor.

**School of American Research
Contemporary Indian Artists Series**

Duane Anderson
Series Editor

Indian Basketry Artists of the Southwest

Annie Antone
Tohono O'odham (Papago)

Mary Holiday Black
Diné (Navajo Nation)

Sally Black
Diné (Navajo Nation)

Lorraine Black
Diné (Navajo Nation)

Rikki Francisco
Akimel O'odham (Pima)

Joseph Gutierrez
Santa Clara Pueblo

Abigail Kaursgowva
Hopi, Third Mesa

Remalda Lomayestewa
Hopi, Second Mesa

Kevin Navasie
Hopi, First Mesa

Molly Pesata
Jicarilla Apache

Indian Basketry Artists of the Southwest

Deep Roots, New Growth

Susan Brown McGreevy
With a Foreword by Kevin Navasie

School of American Research Press
Santa Fe, New Mexico

School of American Research Press
Post Office Box 2188
Santa Fe, New Mexico 87504-2188
www.sarweb.org

Acting Director: Cynthia Welch
Editor: Joan K. O'Donnell
Copy Editor: Jo Ann Baldinger
Design & Typography: Context Design, Galisteo, NM
 Concept: Edvin Yegir & Tom Morin
 Art Direction & Design: Tom Morin
 Typography: Isabella Gonzales
Printer: Sung In Printing

Library of Congress Cataloging-in-Publication Data:
McGreevy, Susan Brown, 1934-
 Indian basketry artists of the Southwest:
 deep roots, new growth / Susan Brown McGreevy.
 — 1st ed.
 p. cm. — (Contemporary Indian Artists Series)
 Includes bibliographical references.
 ISBN 0-933452-67-5 (pbk.)
 1. Indian basket makers — Southwest, New.
 2. Indian baskets — Southwest, New. I. Title.
 II. Series

 E78.S7 M37 2001
 746.41'2'08997079 — dc21

 00-067985

Cover: Top, Coiled tray by Lorraine Black, Diné,
1996. Private collection. Bottom, Coiled tray by
unknown Akimel O'odham basket maker, ca. 1920s.
IAF.B31. Photographs by Addison Doty.

Printed and Bound in South Korea.

Dedicated to Andrew Hunter Whiteford

Contents

3 Participating Artists

9 Foreword *by Kevin Navasie, Facilitator*

10 Series Introduction *by Duane Anderson*

13 The Foundations

46 The Artists

84 The Gathering

92 Suggestions for Further Reading

94 Acknowledgments

95 Picture Credits

Foreword

We shared some of the little things we have hidden deep down in our artist's hands....
We shared little secrets we all have as individual basket makers at the School of
American Research' Gathering of Artists at the Deep Roots, New Growth: Southwest
Indian Basketry. It was such an amazing learning and creative experience for every-
one. What I heard from others of different Native American cultures motivated me as
a contemporary artist and basket maker, and gave me a greater respect for my art. It's
hard for me to express in mere words what took place. The baskets and their history
came to life. I found myself drifting back to the thoughts and traditions of my people.
Being the youngest participant, I was inspired by the elders that were there with me,
exchanging ideas, sharing histories, helping me to learn how to blend new ideas with
old. I was moved by their efforts to continue to make baskets. I learned about the tools
they used which were both distinct and similar at the same time. They are helping to
keep our cultures alive. As a contemporary artist, I gained strength in their wisdom
and gathered new ideas for my baskets.

—Kevin Navasie, Hopi

Introduction

Each Contemporary Indian Artists gathering at the School of American Research (SAR), informally known as a "convocation," has presented unique challenges. Participants in the convocation on micaceous pottery, for example, met during a period of rapid and often stressful change, as their long-standing cooking ware tradition was being transformed into a new art-pottery form. As a result, issues of tribal identity, copyright, access to clay sources, and the appropriateness of teaching pottery traditions to outsiders dominated their conversations. At a time when the artists were experimenting and trying to respond to market influences and produce new kinds of pottery, many buyers were looking for "traditional" vessels such as bean pots and other utility wares.

Basket making is more time-consuming than pottery making. It is also more structured in terms of technique and, as a result, much more resistant to change. One question that arose at the basketry gathering was "What constitutes 'innovation' within this inherently conservative tradition?" Within Southwestern Indian communities today, there seems to be a greater emphasis on perpetuating traditional basketry arts than on creating new forms or experimenting with new materials, pigments, or design motifs. A common complaint among the artists was that prices do not reflect the amount of work involved in making baskets. They also lamented how difficult it is to get today's young people interested in traditional arts and crafts.

In assembling the list of invited artists, an effort was made to include respected innovators and people from varied cultural backgrounds who were working with different raw materials and using different methods. Participants were asked to bring examples of their tools and raw materials to the gathering. This allowed them to demonstrate manufacturing methods to each other in a way that enhanced their appreciation for the many coiling and plaiting techniques in use in the Southwest. We were fortunate that facilitator Kevin Navasie was able to attract talented artists from Arizona (Tohono O'odham, Akimel O'odham, and Hopi), Utah (Diné), and New Mexico (Santa Clara Pueblo and Jicarilla Apache). All the participants made significant contributions to the convocation, and their baskets have been incorporated into

the collections of SAR's Indian Arts Research Center. Collectively, they constitute one of the finest and best-documented assemblages of Southwestern basketry anywhere—one that will be of lasting value to students interested in the broad scope of Native American aesthetics and creativity.

Susan Brown McGreevy and Andrew "Bud" Whiteford were to be co-authors of the proceedings. Unfortunately, Bud suffered a stroke and was unable to work on this book. Susan recorded and documented the gathering and completed the manuscript. Her dedication of the book to Bud is a fitting tribute to his love of baskets and his many scholarly contributions on the subject.

—Duane Anderson

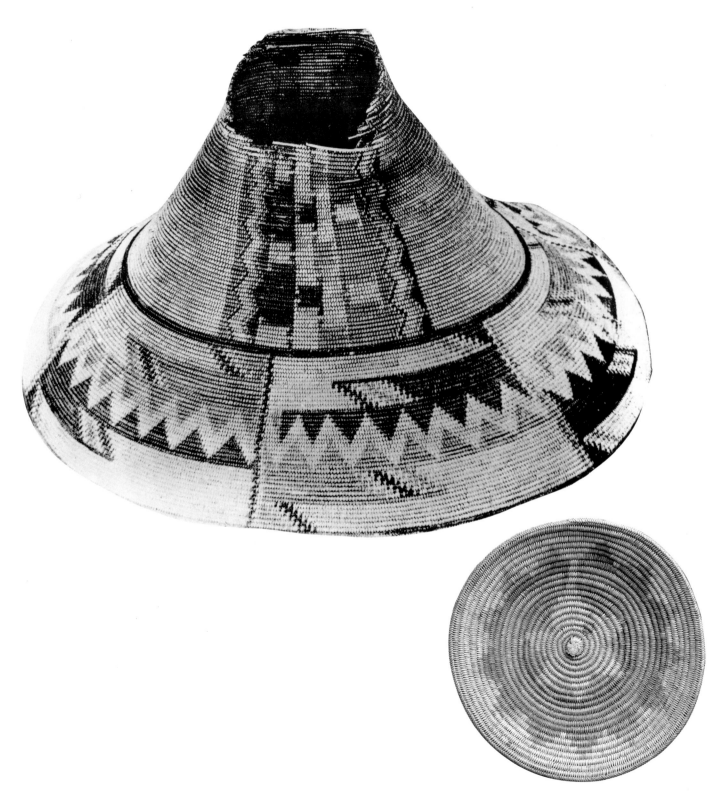

The Foundations

< TOP
Coiled Burden Basket from
Pictograph Cave, Canyon del Muerto,
Arizona. Basketmaker III, about
CE 550–700.
The prehistoric Basketmaker
period is aptly named for the large
number of finely made vessels
that have been recovered from
archaeological sites. As pottery
making became more prevalent,
ceramic containers gradually
replaced baskets for most
utilitarian functions.

Coiled Tray, Navajo, date unknown.
Sumac coils and foundation,
commercial dyes. Height: 8.8 cm (3"),
diameter: 38 cm (15").
SAR 1981-25-5.
The wedding-basket style shown here is
the most familiar Navajo basketry
design. The distinctive break or path-
way (*'atiin*) is an essential element for
all baskets used in ceremonies. The
herringbone rim finish is also charac-
teristic of Navajo baskets.

Deep Roots

Basket making is deeply rooted in Southwestern Indian cultures. Archaeological evi-
dence indicates that small groups of nomadic Indians, known collectively as the Desert
Archaic peoples, were making and using baskets as early as eight thousand years ago.
The invention of baskets provided the means for gathering, processing, storing, and
serving wild plant foods. By about 500–700 CE (Common Era, beginning AD I),
peoples living in the Southwest were producing many baskets for a variety of house-
hold tasks. Because of the number of finely made baskets that have been recovered
from archaeological sites, scholars refer to these peoples as the Basketmakers. In all
probability the Basketmakers evolved into the Anasazis, or Ancestral Pueblo people,
the ancestors of today's Pueblo groups. As the Ancestral Pueblos became increasingly
sedentary and conversant with pottery-making techniques, ceramic vessels gradually
replaced baskets for most utilitarian functions, although baskets continued to be made
on a limited basis.

For other groups that later inhabited the Southwest, baskets played an integral
role in the everyday lives of the people. The relationship between baskets and humans
was as direct as the food the people put in their mouths. Baskets also were used to
transport building materials, firewood, water, and even babies. This multipurpose use-
fulness helps to explain the persistence of basket making until the early twentieth
century. And it is the diverse functions of baskets that explain variations in shape and
construction. In some instances ceremonial activities have been responsible for the
longevity of certain kinds of baskets. Among the Navajos (Diné), for example, the
wedding basket serves a variety of ritual functions. The use of the burden basket in
an Apache girl's coming-of-age ceremony provides a compelling reason for the
persistence of this form. Basketry bowls carry bread and other foods to the kivas dur-
ing feast days, and baskets play a major role in the Basket Dances at Hopi and in the
Rio Grande Pueblo villages.

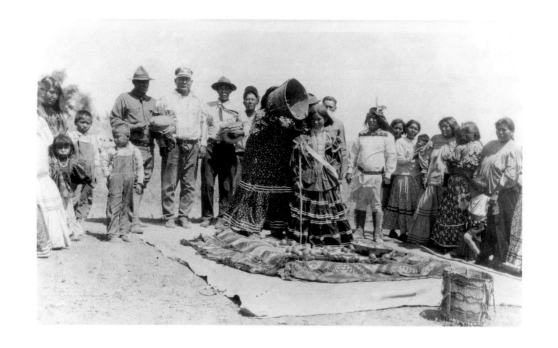

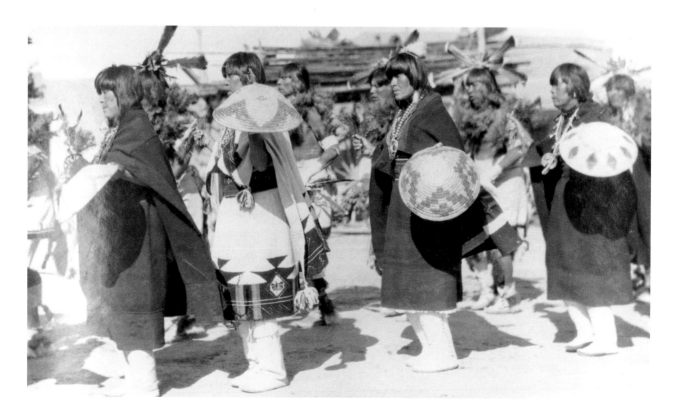

New Growth

The opening of the Santa Fe Trail in 1821 brought an influx of trade goods into the Southwest, with a resulting impact on the history of Indian basketry in the area. As a variety of metal containers became available, there was a concomitant decrease in local reliance on native-made baskets for household use. The arrival of the railroad in the 1880s further increased the supply of manufactured goods and threatened the very survival of handmade baskets. At the same time, however, the trains brought tourists, creating a lively demand for Indian-made souvenirs. The first trading posts were established during the late nineteenth century and soon provided additional markets for Native American craft arts. Thus there were unprecedented incentives for Southwestern Indian basket makers to practice their art. Baskets in new shapes, sizes, and colors began to appear. Numerous curios were made for the tourist trade, but as the collector's market became more stable and tastes more sophisticated, the quality of basketry improved.

In recent years, the vitality of the Indian art market has encouraged a renaissance of basket making. Today the sale of baskets is a significant factor in the survival of the art among many tribes. In addition to providing income, basket making also generates collective and individual pride and serves to reinforce cultural values and ethnic identity. Trading posts, galleries, museums, and private collectors all play roles in supporting and encouraging contemporary basket makers. In most tribes, basket making traditionally has been a woman's art, but in response to the rewards of the art market, there also are a few male basket makers currently working. While older design traditions have endured, exciting new images have entered the repertoire. The venerable canon of tribal styles provides a rich inventory of ideas, but the venture into the territory of new designs requires an open mind and a willingness to take risks. Above all, basket making remains a creative endeavor.

Honoring Mother Earth

The raw materials for basket making come from many kinds of plants and parts of plants, including roots, tree branches, bushes, pods, grasses, and yuccas. The bond that connects the plants of the earth and the makers of baskets is at once personal and spiritual. Perhaps more clearly than in any other Southwestern Indian art, collecting materials for use in basketry reflects an intimate relationship between

SOUTHWESTERN PLANTS COMMONLY USED IN BASKET MAKING*

MATERIALS

The raw materials for basket weaving come from many kinds of plants, including bushes, grasses, and yuccas, and parts of plants, from roots to branches. Each weaver must have an intimate knowledge of plant life and an abundance of patience. Aspiring young basket makers usually learn from their mothers or grandmothers and must help with the tasks of gathering and processing materials before they can make their first baskets. Although natural dyes were used by most groups in the past, today many basket makers prefer to save time by using commercial dyes.

PLANTS MOST COMMONLY USED

Alder bark (*Alnus incana*): produces red, tan, and brown dyes.

Beargrass (*Nolina microcarpa*): foundation for Tohono O'odham coiled baskets.

Cattail stems (*Typha angustifolia*): foundation for Akimel O'odham coiled baskets.

Desert Willow (*Chilopsis linearis*): Tohono O'odham—used rarely today for coiling.

Dune Broom (*Parryella filifolia*): warp for Third Mesa Hopi plaited wicker baskets.

Chamisa or Rabbit Brush (*Crysothamnus nauseosus*): weft for Third Mesa Hopi baskets.

Fremont Cottonwood (*Populas fremontii*): warp for Western Apache twined baskets.

Galleta Grass (*Hilaria jamesii*): foundation for Second Mesa Hopi coiled baskets.

Martynia, Devil's Claw, Unicorn Plant (*Proboscidea parviflora* or *louisiana*): used for black decorative accents by the Apaches and O'odhams, among other groups.

Mormon Tea (*Ephedra viridis*): produces a red-brown dye.

Mountain Mahogany roots (*Cercocarpus*): used to make a reddish dye.

Sunflower seeds (*Helianthus annuus*): used by some Hopi women as a black dye.

Three-lobed Sumac (*Rhus trilobata*): foundation and coiling material for Navajo, Jicarilla Apache, and San Juan Paiute baskets. Weft for some Western Apache twined baskets.

Willow (*Salix*): coiling material for Akimel O'odham and Western Apache baskets; occasionally also used by Navajos and Jicarilla Apaches. Red willow is used by the Rio Grande Pueblos for bowl-shaped baskets.

Yucca (*Yucca baccata and elata*): coiling material for Second Mesa Hopi and Akimel O'odham baskets. Sifter baskets also are made with yucca. Yucca roots are used to make a reddish dye.

*adapted from Barbara Mauldin's *Traditions in Transition*

Minnie Dick, a Paiute basket maker from Lee, Nevada, gathering willow to use in basket weaving.
Photo by Carol Edison.

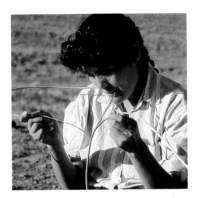

Sally Black (Diné) splitting willow splints.
Photo by Carol Edison.

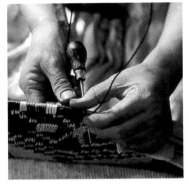

Mary Holiday Black (Diné) making a coiled willow basket.
Photo by Carol Edison.

human society and the natural world. The knowledge that each basket maker must acquire about plant life is passed down from generation to generation.

Often young basket makers must help with the tasks of gathering and processing before they are permitted to create their first basket. A young girl will accompany her mother or grandmother on plant-gathering expeditions in order to learn what plant grows where and which plants are best for the task at hand. She must also learn the best time of year to gather her materials; some are best when the sap is down, others when the first tender buds appear. The intellectual challenge of discovering and identifying plants is a part of every basket maker's experience from an early age.

The ethos of most native peoples in the Southwest mandates that human beings maintain a harmonious and balanced relationship with all aspects of the universe. Furthermore, all things in the universe are considered to be related; humans are kin to Mother Earth, Father Sky, and their offspring, the Plant People. This pervasive worldview is particularly relevant to collecting basketry materials. The process is never indiscriminate, always respectful. Plants are judiciously pruned rather than randomly harvested. The spiritual connection between the basket maker and Mother Earth is further honored by certain ritual observances associated with the collecting process. The gathering of materials is dictated not only by the optimal time for harvesting, but also by consideration for Mother Earth and the plant life she nourishes. Renewal of the earth and her resources is of critical importance. As convocation facilitator Kevin Navasie explained, "There is a time we collect and a time when we don't collect, when we let the earth and everything rest."

From Plant to Art

Gathering materials is a time-consuming endeavor. After the plants have been collected, they must be processed—another labor-intensive activity. To produce thin, flexible sewing splints of sumac or willow, first the bark is removed. The bare stick, or osier, is then placed between the front teeth, and three strands are fashioned by pulling two splints from the center, using thumb and index finger. This delicate manipulation continues until sufficient splints have been processed. Materials are occasionally used

Lydia Pesata's dye-plant materials before "cooking," and cooked plant dyes (at bottom).

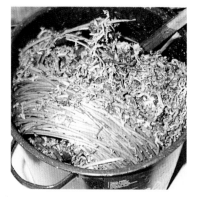

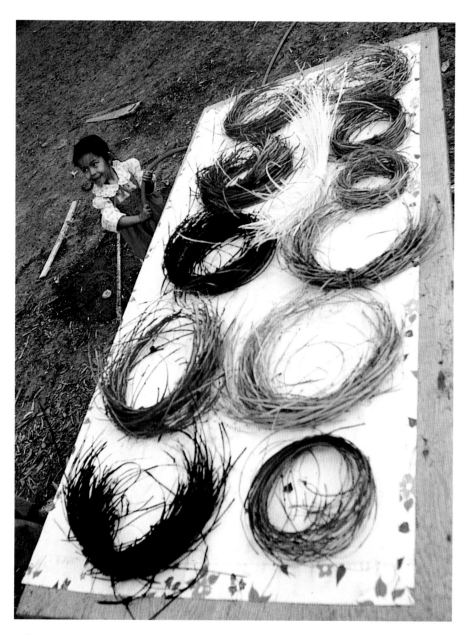

Lydia Pesata's dyed basketry materials. Left, from bottom: black (sumac leaves and bark); pink (chokecherries); brown (walnut hulls); light rust (lichens and mountain mahogany root bark); reddish (mountain mahogany root bark). Right, from bottom: red brown (alder bark and walnut hulls); yellow (barberry roots); light yellow gray (Oregon grape and Mormon tea); light pink (hollyhocks); light gray brown (Indian tea and sage); light orange (onion skins and lichens).

Simple twining (top) and twill, or diagonal, twining.

Plaiting with flexible (top) and rigid materials.

immediately, but more often they are stored for future use. Before basket making can begin, stored materials must be soaked in water to restore flexibility. Although organic and plant dyes were used by most groups in the past, today many basket makers prefer to save time by using commercial dyes. This has two interesting implications for the artist, who as a result is able to make more baskets or spend more time being creative with one basket.

Kevin Navasie reported that among the Hopis, gathering materials has traditionally been limited to the time of year when the katsinas (spirit messengers from the gods) are not present. The search for large yucca plants usually means a day-trip away from the village. When suitable plants are located, only a few leaves are taken from each plant. Each leaf must then be cleaned and split. The upper part, or backbone, is stripped away using an awl. This procedure leaves a flat strip for making the basket. Every part of the yucca is used; nothing is wasted. Shreds left over from splitting are given to Second Mesa basket makers to use in the foundations of coiled baskets. Small pieces also are given to pottery makers from First Mesa to use as paint brushes.

Southwestern Indian baskets are made with three basic techniques: plaiting, coiling, and twining. Twining is the most ancient technique, used among the Desert Archaic peoples as early as 6000 BCE. It is fundamentally a kind of weaving, characterized by a passive warp and an active weft. The slender, flexible weft splints are twined in pairs across alternating rigid warps. Warps and wefts are occasionally separated to make openwork baskets that can be used as sieves. In a slightly more complex technique called twill or diagonal twining, two warps are enclosed within each weft twist, and each twist is moved one warp to the right of the twist immediately below it. The materials used by Archaic peoples were the same as those used today: willow, three-lobed sumac, mulberry, and various kinds of yucca leaves. Because it produces lightweight but sturdy containers, twining often is used to fashion burden baskets, jar forms, and bowls. Today, Western Apache burden baskets are the most common twined vessels made by Southwestern Indians.

Plaiting is another ancient technique in which single strands of plant material are alternately passed over and under each other. The method most likely arrived

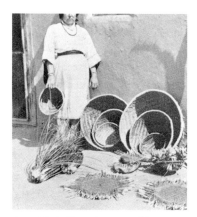

Anna Maria Toya, Jemez Pueblo, 1937.
Toya is standing behind a group
of sifter baskets in various stages of
production.

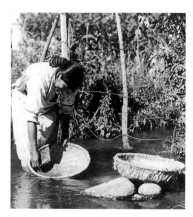

Jemez woman washing wheat in
an irrigation ditch, September 15, 1936.
Photo by Williamson.
Sifter baskets were used for washing
and winnowing grains, as well as for
storing and serving food.

in the Southwest from Mexico. In a variation known as twilled or diagonal plaiting, the elements of one set pass over two or more of the other in staggered intervals. Sifter baskets are plaited with both plain and twilled methods. These containers are also called yucca ring baskets, because the plaited mat is passed through a ring made of cottonwood, willow, or three-lobed sumac. Today some basket makers use a metal ring. The ends of the mat are then cut to an even size and stitched down. Yucca ring baskets date to about 2000 BCE and have continued to be made in virtually the same way up to the present day. Because they are so useful, they will no doubt persist far into the twenty-first century as well. Rio Grande Pueblo wickerwork baskets actually are made by a plaiting method, but using rigid willow osiers rather than flexible materials. Third Mesa Hopi baskets also are frequently referred to as wicker, but they too are fashioned with a plaiting technique.

Coiling can most appropriately be thought of as a sewing technique in which splints made from various plant fibers are literally stitched together over several kinds of foundations (see page 23). Coiling is commonly used for making bowls, plaques, trays, and jars. Foundations may be made of three rods placed together in a triangular configuration. Sometimes a fiber bundle replaces the top rod; this two-rod-and-bundle foundation was used by the Anasazi and Pueblo basket makers. It is also found in older Navajo baskets, suggesting that pre-twentieth-century Navajo basket making techniques were borrowed from Pueblo artisans. During the twentieth century, some Diné (Navajo) basket makers like to stack three to five rods, one on top of the other. The Akimel O'odhams use a bundle of cattail stems, the Tohono O'odhams prefer a bundle of bear grass, and on Second Mesa at Hopi the bundle consists of galleta grass.

The work surface of a coiled basket faces the maker, and coiling usually proceeds from right to left. A sharp awl is used to facilitate the passage of the sewing splint. Before the twentieth century, awls were made from thorns or a sharpened animal bone. These were replaced by needles or other sharpened metal implements, such as screwdrivers, and today factory-made awls are easily purchased at leather or fabric stores.

The coiling technique.

> RIGHT
Third Mesa Hopi woman weaving
a plaited wicker plaque with katsina
design, about 1900.
Photo by A. C. Vroman.
Katsina masks and figures have been
popular motifs on Hopi baskets since
the late nineteenth century.

Willow Wicker Bowl by Tom E. Garcia,
Santo Domingo Pueblo, about 1980s.
Height, 21.5 cm (8"); diameter, 49 cm
(19 1/4"). SAR 1987-6-2.
Wickerwork baskets are made only in
the Rio Grande Pueblos and seem to be
made exclusively by men. They are used
for carrying, storing, and serving foods
such as corn, beans, breads, and fruits.

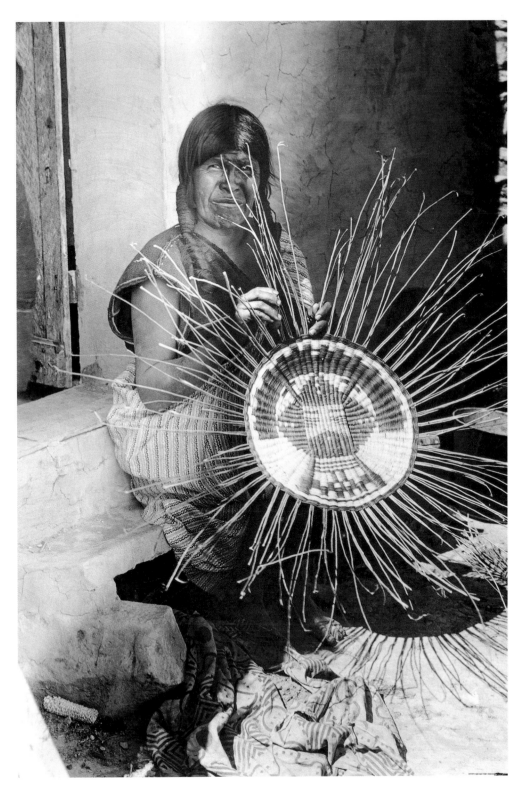

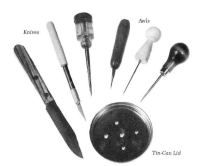

Tools commonly used in contemporary basket weaving.

With the exception of such "modern" tools as pruning shears, scissors, knives, awls, tin lids, and fingernail clippers, the basket makers have no energy- or time-saving devices. But in spite of the labor-intensive investment, most basket makers find great satisfaction in the artistic and intellectual challenge of creating something beautiful. Furthermore, the activities of gathering and processing materials and making baskets frequently are sociable occasions, offering opportunities to share gossip, family stories, jokes, and companionship.

Basketry designs derive from a variety of sources. Some are inspired by dreams, others by images from nature. Today many basket makers visit galleries, libraries, and museums to study the work of other basket makers or artists working in different media. In most cases, the complete design is conceived within the mind of the artist and transferred to the basket without the aid of sketches or measuring devices. Occasionally a basket maker will use hand measurements to achieve more precise spacing. Far more than the sum of its various influences, every basket is a personal statement of individual creativity and artistic integrity. Each basket maker has a story to tell, filtered through the lens of her life experiences, imagination, and originality. Historic baskets held things, today's baskets hold ideas.

Throughout most of the history of Indian basketry, the makers have been anonymous. Basket making was considered to be part of everyday life rather than a separate artistic activity. In recent years, however, as baskets increasingly are viewed as art works by collectors, museums, and galleries, the most talented basket makers have enjoyed name recognition.

Even though basket making has become a profitable activity, however, the primary incentive continues to be found in the creative process. The act of transforming plant fibers into works of art demands great skill, infinite patience, and refined aesthetic sensibilities.

Tohono O'odham and Akimel O'odham
starts. Drawings by Arminta Neal.

Herringbone rim finish. Drawing by
Arminta Neal.

Hopi diagonal start by Abigail Kaursgowva.

Starts and Finishes

Some Native American groups have distinctive ways to begin and end their baskets.
While not necessarily definitive, in most instances they can provide helpful clues to
the cultural origin of the basket. These diagnostic traits are most useful for identifying
historic (late-nineteenth- and early-twentieth-century) baskets. For example, the
Tohono O'odhams (Desert People, formerly known as Papagos) often use a plaited
square start. This method is also used by their relatives, the Akimel O'odhams (River
People, formerly known as Pimas), but not as consistently. Because the rim of the bas-
ket is the part most vulnerable to wear, the Piman-speaking peoples use devil's claw
for the rim finishes, most often in an overlay stitch, but sometimes with a braid.

Traditional Navajo baskets feature a false braid or herringbone finish. Dr.
Washington Matthews, an army surgeon posted at Fort Wingate near the Navajo
Reservation in the late 1800s, collected a story about this rim finish. It seems that
Talking God (an important Navajo sacred being) provided a Navajo basket maker with
a spray from a juniper branch to inspire her to finish her basket in a unique method.
Today some Navajo weavers occasionally finish their baskets with an overlay stitch,
while others use a cross-stitch. Mary Holiday Black explained that the start of a Navajo
basket represents the pattern of the fingerprint whorl and has its origins in the cre-
ation story. "This is how the world began," she said, "as a coil."

Third Mesa wicker basket makers have a choice of two kinds of starts. In the
first, a number of warp sticks are laid parallel to each other and held together by the
more flexible weft strands. The basket maker frequently places the warps between two
boards that have been specifically designed to hold the sticks in place. Another start is
then made in similar fashion, and the two are fastened together by additional weft
material. This creates a distinctive bulge in the center of the basket. An older, simpler
way of beginning the basket was demonstrated by Abigail Kaursgowva during the
convocation. This method has diagonal or stepped warp sticks that are fastened
together by the weft.

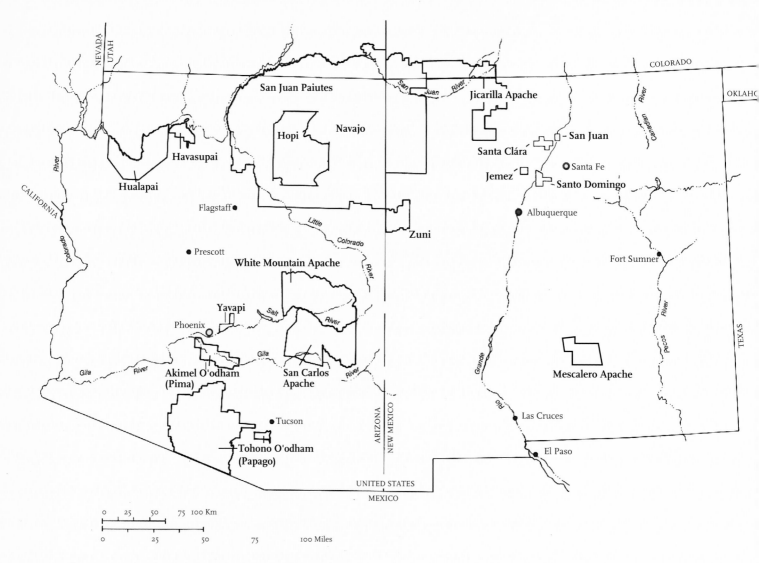

Locations of contemporary
Southwestern Indian basket weaving groups.

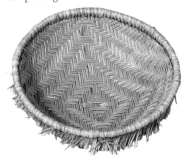

Plaited Sifter Basket by Leonardo Toledo, Jemez Pueblo, 1968. Yucca ring basket. Height, 14.6 cm (5 3/4"); diameter, 36.9 cm (14"). IAF B446. Jemez basket makers utilize the whole, unsplit yucca leaf and use two strands for plaiting.

Basket-Making Groups

For the most part, the groups represented in this section reflect the tribal identities of the convocation participants. There are two exceptions. The San Juan Southern Paiutes have been included, in recognition of SAR's large, excellent collection of contemporary baskets by this group. The San Carlos Apaches are also mentioned, since a San Carlos basket maker was invited to the convocation; unfortunately, she was unable to attend.

The Rio Grande Pueblos

Basket making decreased in importance in the Southwest with the development of pottery making, beginning about 700 CE. When the Spaniards arrived in the region in the sixteenth century, they encountered small communities of village-dwelling farmers. The Spanish word for town or village, *pueblo*, became the generic term for these indigenous peoples and their settlements. Although the inhabitants of the pueblos were making a variety of pottery vessels, basketry arts were negligible, a trend that for the most part has continued to the present.

There are three basket styles still being made in the Rio Grande pueblos, where most of the basket makers are men. During the nineteenth and twentieth centuries, coiled baskets were made by a few men in several villages. Yucca ring baskets have been continuously produced since prehistoric times for the daily tasks of food preparation and serving. They remain so useful for a variety of purposes that both men and women in numerous villages continue to make them today.

Plaited wicker containers, made from red willow branches, are different from any other kind of basket found in the Southwest. Since there is no precedent for this type of basket in either the prehistoric or protohistoric inventory, most authorities agree that it is most likely of European origin. The style can be found from Scandinavia to Italy. It has been suggested that perhaps the prototype was invented by gypsies, which might explain the wide distribution of these baskets. Because the technique is so universal, however, it seems possible that it might have been independently invented by the Rio Grande Pueblo groups. Red willow baskets were also used by Hispanic peoples of northern New Mexico, where woodcutters from Truchas, Trampas, and other mountain villages sold them along with their wood. It is not clear whether these

Pascual Martinez, San Ildefonso Pueblo, about 1917. Photo probably by Kenneth M. Chapman.
Martinez is standing behind two of his wickerwork baskets made from willow splints. He was particularly known for his large baskets.

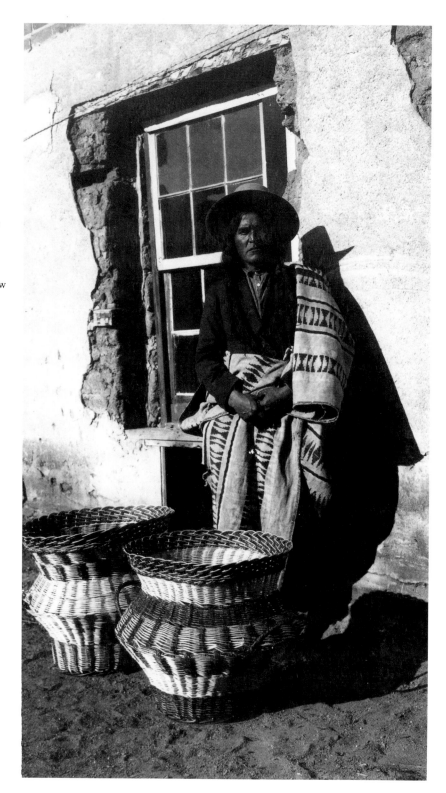

Large Willow Wicker Bowl by Pascual Martinez, 1912. Height, 30.5 cm (12"); diameter, 81.3 cm (32"). Collected by Kenneth M. Chapman. IAF B123.

villagers also made the baskets or simply bought or traded for them with Pueblo peoples. Today these attractive baskets are made by Rio Grande Pueblo men in several villages. Variations in color are accomplished by juxtaposing unpeeled and peeled osiers. Pueblo residents use these baskets for carrying, storing, and serving food at home and in the kiva on feast days. They are also used in Basket Dances and are frequently hung to decorate the walls of Pueblo homes. In the early part of the twentieth century, Pasqual Martinez of San Ildefonso Pueblo was known for his large wicker baskets with elegant shapes.

THE HOPIS

The tradition of Hopi basket making, which can be traced back at least 1500 years, seems to have the longest continuity in the Southwest. The Hopi people live in northern Arizona in villages built on fingerlike extensions from a massive land formation called Black Mesa. From east to west, they are known as First Mesa, Second Mesa, and Third Mesa. The effort of subsisting in this harsh, beautiful, and demanding landscape depends on cooperation from the grudging earth in the form of crops, from the skies in the form of snow and rain, and from the people, in the form of a complex set of ceremonial observances and reciprocal social obligations.

Baskets play an integral role in the social matrix and ceremonial calendar of Hopi village life. Each year the katsinas arrive at winter solstice and depart after summer solstice. They come to help the Hopis in the guise of masked impersonators. One of their most significant functions is the production of rainfall. Rain is literally the stuff of life for the Hopis, nourishing the crops that nurture the people.

During two of the major ceremonies, known to Anglos as Bean Dance and Home Dance, the katsinas distribute gifts to the children. Little girls receive katsina dolls and baskets, little boys are given drums and bows and arrows. Bean Dance begins when Crow Mother katsina emerges from the kiva carrying bean sprouts in a basketry bowl. During Bean Dance, ogre katsinas collect foodstuffs in a wicker burden basket. The food is later redistributed in the kiva. The ceremonial cycle ends in October with the public Basket Dances of the women's societies. Basket Dances are in part performed to anticipate prosperity for the coming year, so generous giveaways are part of the ceremony.

Wicker *Piiki* Tray by DoraTawahongua, Third Mesa Hopi, 1984. Sumac weft and warp. Length, 61 cm (24"); width, 49 cm (19 1/4"). SAR 1984-5-1. Among the Hopis, *piiki* trays are the second most commonly used baskets today. Paper-thin blue corn *piiki* dough is served on trays like this at all important Hopi ceremonial occasions.

Although utilitarian baskets such as sifter baskets, *piiki* trays, baby cradles, and burden baskets are still made in modest numbers, for the most part basketry production focuses on wedding paybacks, gift giving, and Basket Dances. Grandmothers give special basketry plaques to newborn granddaughters, and plaques continue to be presented until the girl reaches the age of initiation. During initiation ceremonies, the girl grinds corn, using a mano and metate, for four days, and on the fifth day a basket holding the cornmeal is presented to her grandmother. Plaques also are given for birthdays, anniversaries, and other special events.

The wedding payback is by far the most important basket-giving occasion. Men in the groom's family are responsible for weaving the bride's wedding robes, an activity that can take many months or even several years to complete. After the wedding robes are presented, the bride and her family respond with great numbers of baskets and foods of various kinds. Three baskets are mandatory and must be kept by the groom: a large wedding plaque filled with white cornmeal, a smaller plaque that holds yellow cornmeal, and a *piiki* tray, loaded with *piiki* bread. The groom must keep the wedding plaque to use as the vehicle on which his spirit travels after he dies.

Hopi basket makers, who traditionally have been women, use three different techniques. The ever-useful plaited sifter basket is made on all three mesas, where it is used to hold and store food, as a colander for washing corn and beans, and as a receptacle for drying peaches and other fruits. The other two types are mesa-specific: the coiled baskets of Second Mesa and the wicker baskets of Third Mesa. The coiled baskets of Second Mesa are made of yucca splints over a galleta grass foundation. These baskets are fashioned in two basic shapes: jar-forms and plaques. Designs on both forms vary from geometric motifs to animal images and elaborate depictions of katsinas. Second Mesa wedding baskets are made with a star or flower design and must only use natural green, white, and black colors. They are purposely left unfinished so that the marriage will continue to grow.

Baskets produced on Third Mesa are made with a plaited wickerwork technique. Wickerwork plaques are most frequently made with bold geometric patterns and katsina designs. In order to achieve the bright colors preferred by Third Mesa basket makers, aniline dyes often are used. The design on Third Mesa wedding

Coiled Jar, Second Mesa Hopi, about 1890–1910. Yucca coils, galleta grass foundation, natural dyes. Height, 41 cm (16 1/4"); diameter, 45.8 cm (18"). SAR 1984-4-38.

Basket makers in the villages of Second Mesa specialize in coiled baskets. This large jar form, depicting clouds and a Crow Mother katsina, is a unique and beautiful example.

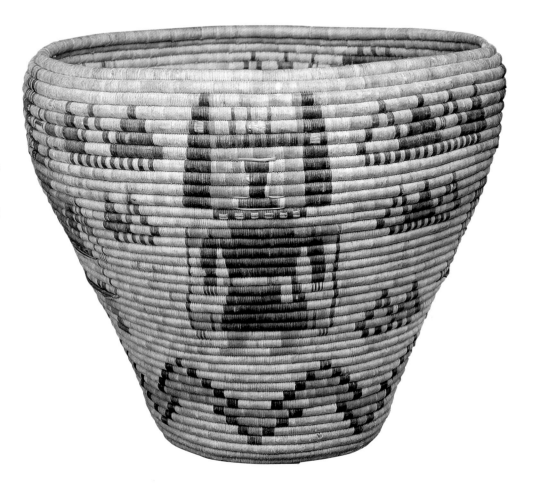

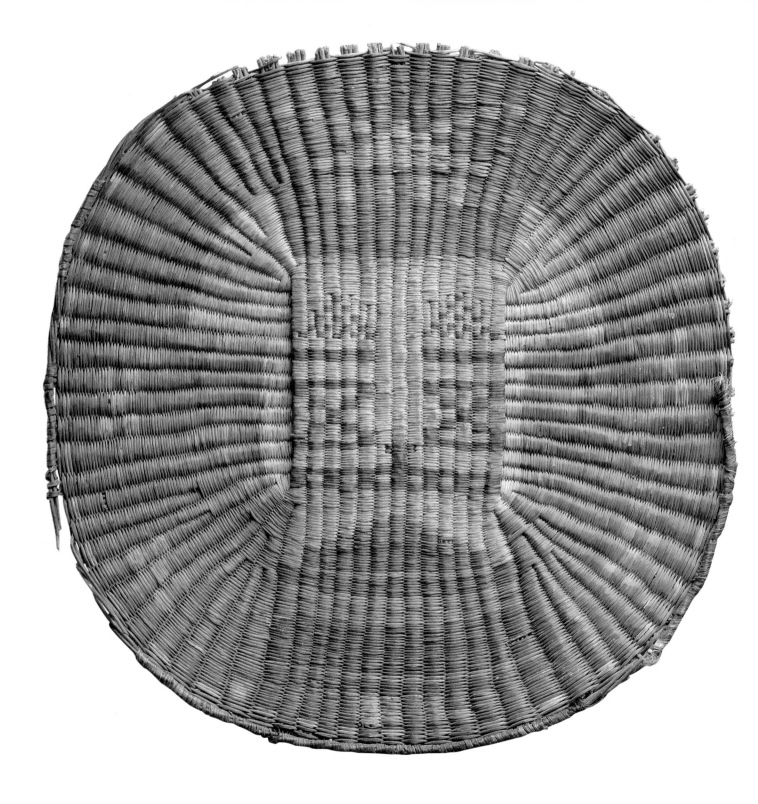

plaques symbolizes the links that connect the couple together. The most common materials for these baskets are rabbit brush and dune broom. It should be noted that both the Latin (*Parryella filifolia*) and Hopi (*siwi*) names for this plant are well established. Not everyone agrees that the plant commonly referred to as dune broom is indeed the material used. Although early literature refers to the material as sumac, the Hopi basket makers in the convocation compared their *siwi* with the sumac that the Navajos were using and agreed that it was a different substance.

THE NAVAJOS (DINÉ)

The Navajos call themselves the Diné, meaning the People. According to most archaeologists, small groups of these Athabascan-speaking peoples migrated from north-central Canada to the Southwest sometime between 1200 and 1500 CE. Early Spanish chronicles indicate that Navajos were trading their baskets and other items to the Pueblos by the early seventeenth century.

Prior to the twentieth century, Navajo women made three kinds of baskets. Two of these are no longer made: a twined or coiled burden basket used for collecting wild and cultivated plant foods, and a coiled basketry jar, coated inside and out with piñon pitch, used for transporting and storing water. The third type of basket, a coiled basketry bowl or tray called the *ts'aa'*, continues to be made today using three-lobed sumac splints sewn around a sumac rod foundation. Traditionally the *ts'aa'* was coiled in a "sunwise" (clockwise) direction to conform to ceremonial mandates, but since this is very difficult for a right-handed weaver to accomplish, gradually basket makers shifted to a counter-clockwise coil.

Although it was customarily used for utilitarian purposes, the *ts'aa'* also had several important ceremonial functions. The Navajo origin narrative relates that the Diné emerged into this world after passing through a series of underworlds. Ceremonial use of the *ts'aa'* was established by sacred beings, or Holy People, at some time during the Emergence. Furthermore, the Navajo creation story explains that thinking and planning are prerequisite to the act of creating anything. For the Navajos, the creative process is part of everyday life, guided by the fundamental precept of *hozho*, a profound philosophical belief that integrates balance, order,

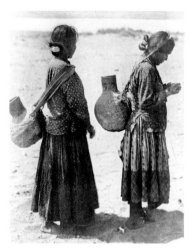

Navajo girls carrying water, Arizona, ca.
1900. Photo by George Wharton James.
Coiled water jars like these, coated
inside and out with piñon pitch, were
used by the Navajos until the early
twentieth century, when they were
replaced by factory-made goods.

harmony, and beauty. Thus Navajo creativity embodies Navajo cultural values.

Washington Matthews in 1902 provided the earliest descriptions of the two basic designs that he found on coiled basketry trays. One featured four crosses, a pattern referred to as the Spider Woman cross or rain cross. Matthews observed that this basket's primary use was for holding sacred cornmeal. Several medicine men report that baskets with this design are used particularly in rituals that relate to precipitation. Many older baskets have a cloth plug in the bottom so that the cornmeal or other contents will not spill out.

The second design that Matthews noted in 1902 featured "a band of red and black with zigzag edges"—a description conforming to the most recognizable pattern associated with the *ts'aa'*, the so-called wedding basket design. This decorative style is one of the few basketry patterns that is said to have symbolic significance. One interpretation describes the white center as the beginning of life moving outwards, the black stepped terraces as clouds and mountains, and the red circular band as the rainbow. Mary Holiday Black has a slightly different explanation. "There is a story to the design," she says. "The center is the center of the earth. There is a rainbow with mountains below it and clouds above it. The outside is the outside of the earth." The ceremonial break (in Navajo, *'atiin*, meaning roadway or pathway) is a mandatory design element that helps the medicine man orient the basket to the east and provides a pathway for healing. Some basket weavers say that it is symbolic of the Emergence and also provides an exit for their creative energies, so "the mind can remain free" to make more baskets.

Wedding baskets are used to serve the special cornmeal mixture during marriage nuptials and also play important roles in other Navajo ceremonies. They hold ritual paraphernalia, serve as an essential part of the payment to the medicine man, and form portions of certain masks. Inverted, they can act as resonance chambers or drums. Today the *ts'aa'* continues to be made to meet ceremonial needs, even as other baskets with innovative designs have become increasingly prevalent.

Traders have played an important role in encouraging and supporting new ideas. In recent years, there has been an explosion of exciting designs that seem to come from everywhere and anywhere: ceremonial iconography, Navajo textile

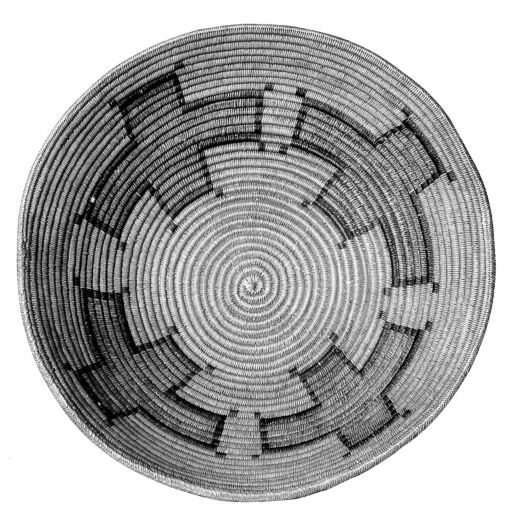

> TOP

Coiled Tray, Navajo, date unknown.
Sumac coils and foundation, commercial dyes. Height: 10.8 cm (4 1/4");
diameter: 34.9 cm (13 3/4"). Collected
by H. P. Mera, 1941. IAF B232.
This Spider Woman or rain cross
motif is an old one that is still popular
with modern basket makers. Baskets
with this design are used in rain
ceremonies.

Coiled Tray, Navajo, date unknown.
Sumac coils and foundation, commercial dyes. Height, 10.3 cm (4"); diameter, 30 cm (12"). Collected by H. P.
Mera, given to SAR in 1941. IAF B199.
This older basket, with the so-called
propeller pattern symbolizing the
sun's rays, is a variation on the
wedding basket design. It contains a
ceremonial break and hence would
have been eligible for ritual use.

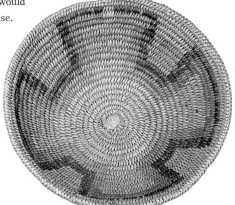

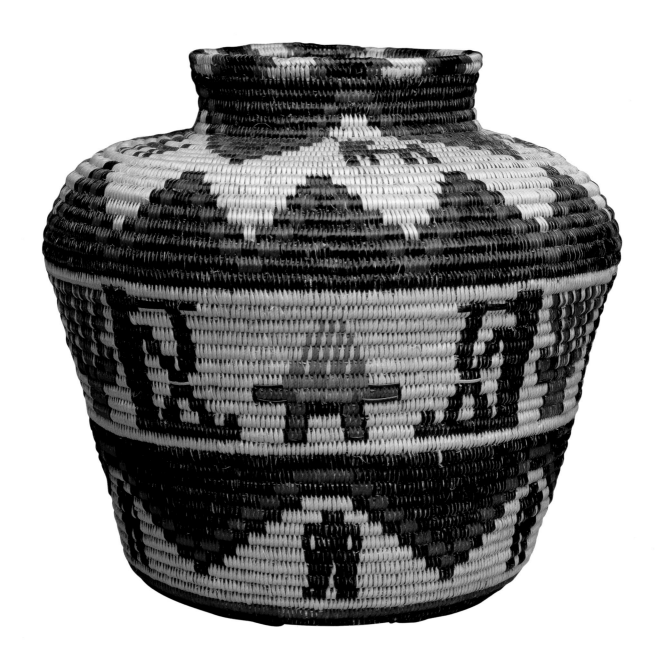

Mabel Lehi, San Juan Paiute, using a seed beater, 1985.

<

Coiled Jar by Sally Black, 1988. Sumac coils and foundation, commercial dyes. Height, 37 cm (14 1/2"); width, 42 cm (16 1/2"). Wheelwright Museum of the American Indian 43/520.
Sally Black's design features Kokopelli, the Ancestral Pueblo humped-back flute player, interspersed with hearth fires and trees.

patterns, animal motifs, scenes from nature, and Anasazi rock art. Navajo basket makers seem to be particularly receptive to exploring new ideas.

THE SAN JUAN SOUTHERN PAIUTES

The San Juan Southern Paiutes are a small tribe of slightly more than two hundred people. They live in two areas of northern Arizona, surrounded by the much larger Navajo Nation. An important aspect of the group's need to maintain its cultural identity can be found in their continuing efforts to preserve and perpetuate traditional knowledge. Hence they are one of the few tribes that continue to make and use utilitarian baskets.

For many years the tribe's basket weavers also have made wedding-style baskets to trade with their Navajo neighbors. Since the 1980s, they have produced a profusion of original new designs. Bill Beaver, a Flagstaff trader, has been instrumental in the success of the Paiute basketry renaissance, through his encouragement and support of design innovations. Although contemporary San Juan Southern Paiute baskets reflect the survival of a distinctive tradition, they also establish a modern style that has received wide recognition.

THE APACHES

The Athabascan-speaking Apaches, linguistic relatives of the Navajos, were formerly hunters and gatherers who also cultivated small household farms. Today ranching is their principal source of income, supplemented by timber sales and in some instances by revenues from gambling casinos. The Western Apaches of Arizona are represented by two related groups: the White Mountain/Cibecue and the San Carlos. Two other groups, the Mescaleros and the Jicarillas, live on reservations in New Mexico. Baskets played an important role in the everyday household activities of each of these groups. Today the Western Apaches and the Jicarillas continue the tradition, but, except for one family, basket making is no longer practiced at Mescalero.

Jicarilla Apaches. Ellis and Walpole, in a 1959 article in *El Palacio,* observed that stoutly coiled baskets were made in the Rio Grande pueblos and concluded that "the

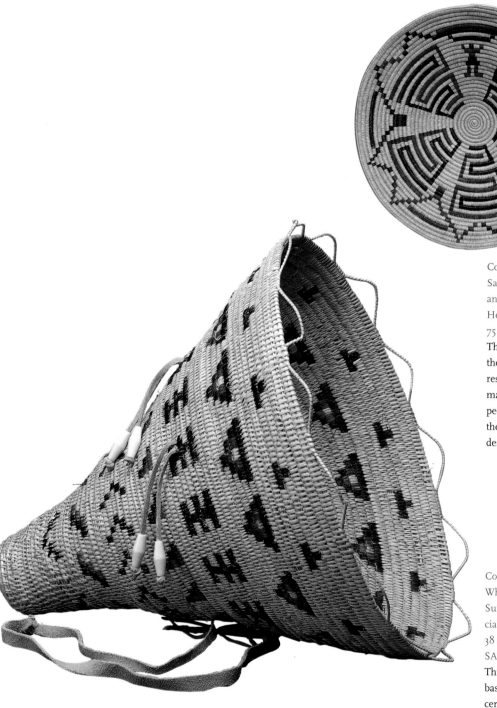

Coiled Bowl by Mary Ann Owl,
San Juan Paiute, 1983. Sumac coils
and foundation, commercial dyes.
Height, 18.5 cm (7 1/4"); diameter,
75 cm (29"). SAR 1986-7-89.
The San Juan Paiutes are known for
their innovative designs. This one
resembles the familiar "man in the
maze" associated with the Piman
peoples. The artist said, "The person is
the Creator, and the five black-and-red
designs are the teachings of life."

Coiled Burden Basket by Rose Ann
Whiskers, San Juan Paiute, 1983.
Sumac coils and foundation, commer-
cial suede, commercial dyes. Height,
38 cm (15"); diameter, 36 cm. (14 3/4").
SAR 1986-7-5.
This elegant version of a burden
basket was made for sale rather than
ceremonial use.

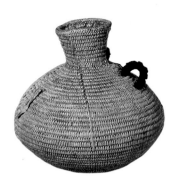

Coiled Water Jar, Jicarilla Apache. Sumac coils and foundation, piñon pitch interior coating. Height, 30.5 cm (12"); diameter, 31.8 cm (12"). Collected by H. P. Mera. IAF B163. This is a typical Jicarilla water container. Unlike Navajo water jars, which are covered inside and out with piñon pitch to make them watertight, Jicarilla baskets are coated only on the inside.

Jicarillas took their basketry concept from this type." More recently, the research of Joyce Herold (personal communication) supports the idea that Jemez coiled baskets may have influenced the development of coiled basketry among the Jicarillas during the twentieth century. Before the twentieth century, Jicarilla utilitarian baskets were frequently made of natural willow or three-lobed sumac splints, boiled with the bark on to produce a mellow amber finish. Other coiled baskets were produced by the more conventional method of removing the bark. Tightly coiled water jars were common household items. Nineteenth-century Jicarilla baskets were traded and sold to the Rio Grande Pueblo villages and to Hispanic settlers, who valued them for their durability and decorative appeal.

For most of the twentieth century the Jicarillas have engaged in a very creative response to the tourist market, although some design elements have been borrowed from ceremonial baskets. During the 1950s, brightly colored "Jicarilla hampers" were popular collectibles, used in Anglo households as laundry and waste baskets. Today, many contemporary basket makers work for the tribal arts and crafts program making coiled sumac baskets with three- to five-rod foundations. These modern baskets tend to have colorful, bold patterns made with aniline dyes. In recent years, a few Jicarilla women have begun to use plant dyes to achieve a subtler palette. Although this increases both time and work, the results are well worth the additional effort.

Previous studies of Jicarilla baskets have not paid much attention to the ceremonial symbolism of designs. However, Joyce Herold's ongoing research at Jicarilla indicates that mountain and butterfly designs derive from the origin narrative. In addition to offering a "way out" so that the basket maker's creativity will not be trapped inside, the ceremonial break also represents the "original sun ladders" that play a major role in the Jicarilla creation story. The sun's rays are another motif that relates to the same sacred account.

Western Apaches. The White Mountain Apaches and their close relatives at Cibecue live in east-central Arizona. The San Carlos peoples are located nearby, at the southern end of the Salt River Canyon. Both groups made finely twined burden baskets to

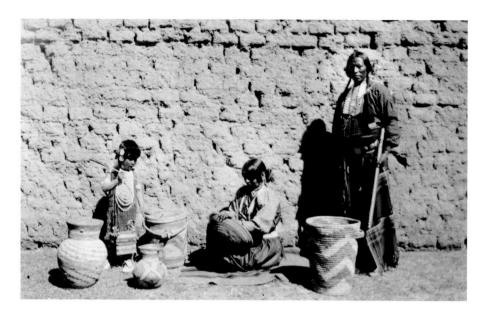

Jicarilla Apache basket maker
and family, about 1915. Photographer
unknown.
The baskets in the photograph are
representative of the early-twentieth
century Jicarilla basketry repertoire.

Hamper, Jicarilla Apache, about 1950s.
Sumac coils and foundation, aniline
dyes. Height, 66.6 cm (26"); diameter,
47.5 cm (18 3/4"). SAR 1978-1-129.
These containers were decorative
as well as useful and became popular
collectibles. Over time the brightly
colored aniline dyes faded to more
muted hues.

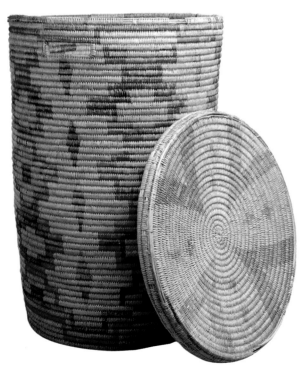

Coiled Tray, Jicarilla Apache, date unknown. Sumac coils and foundation, commercial dyes. Height, 16.5 cm (6"); diameter, 49.8 cm (19 5/8"). IAF B288. The cross pattern resembles a butterfly, the stepped diamonds represent mountains, and the radiating arms suggest the rays of the sun.

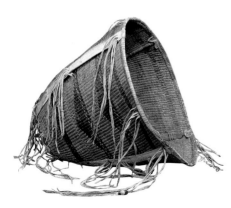

Twined Burden Basket, San Carlos Apache, date unknown. Cottonwood and willow. Height, 43 cm. (17"); width, 43 cm (17"). SAR 1978-1-55. The western Apaches excelled in finely twined containers used for carrying berries, seeds, and other wild foods, crops from cultivated gardens, and firewood. These conical baskets usually had U-shaped frames made with two heavy rods of cottonwood or willow. Many were decorated with buckskin fringes.

carry a variety of domestic essentials. Both groups also produced coiled baskets made of willow splints sewn over a three-rod willow foundation. Late-nineteenth and early-twentieth-century Western Apache coiled baskets were distinguished by skillful command of elaborate geometric and figurative designs executed in devil's claw. There also were a few polychrome baskets that included reddish patterns made from mountain mahogany or yucca roots. Some baskets had eccentric marks that were not congruent with the overall design arrangement. Such marks have been interpreted as signatures, the deliberate avoidance of perfection, or the result of spacing problems. Recent research by Diane Dittemore and Nancy Overgaard, however, has concluded that "answers regarding their significance may be lost to history or may reside in the realm of privileged information."

Although a few coiled baskets continue to be made, today most women (and a few men) specialize in attractive twined work made in jar, bowl, and conical forms. Willow, cottonwood, and mulberry are the plants most frequently used. Some burden baskets continue to be made for use in the Sunrise Ceremony; others are made for sale. Local cultural centers, museums, traders, and galleries actively encourage today's Apache basket makers.

The O'odhams

The two Piman-speaking groups are the Pimas, or Akimel O'odhams (River People), and the Papagos, or Tohono O'odhams (Desert People). Although the O'odham names have been officially sanctioned by both tribes, I will use them and their more familiar Anglo counterparts interchangeably. Most authorities agree that the tribes are the descendants of the prehistoric Hohokam people. Both groups live in southern Arizona in small, scattered family groups that come together for ceremonies and other special occasions. The Akimel O'odhams have long inhabited areas adjacent to the Gila and Salt Rivers. The Tohono O'odhams are denizens of the Sonoran desert, where they practiced *akchin* (run-off) farming, a precarious livelihood that necessitated occasional temporary moves in order to plant and cultivate fields in Akimel O'odham territory. Today many Pimas and Papagos have found wage work in the neighboring cities of Phoenix and Tucson.

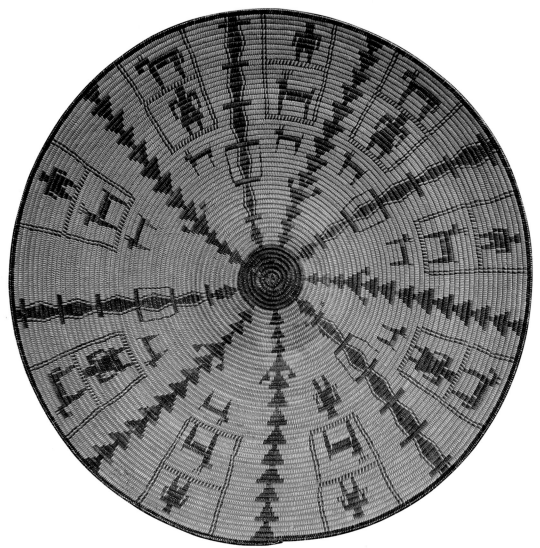

<
Western Apache Tray, about 1920.
Willow splints and foundation,
martynia design. Height, 12.7 cm (5");
diameter, 57.8 cm (22 3/4"). SAR B383.
Figurative designs entered the
repertoire about 1900, most likely in
response to the tourist market.

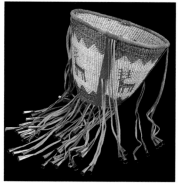

Twined Burden Basket by Evelyn Henry,
San Carlos Apache, 1983. Cottonwood
and willow, commercial suede and tin
tinklers. Height, 35 cm (13 3/4");
diameter at mouth, 42.5 cm (16 3/4").
SAR 1983-8-2.
Today's twined containers frequently
feature animal designs, an innovation
of the last twenty years or so. The
color is achieved by using weft strands
with the bark on. The principal reason
for the survival of these attractive
baskets is their ritual use in the Apache
girl's coming-of-age celebration,
the Sunrise Ceremony.

Akimel O'odham woman
finishing the last coils of a large
granary, about 1900. Photo by Putnam
and Valentine.

The coils of wheat straw are
sewn together with spaced stitches
of mesquite bark.

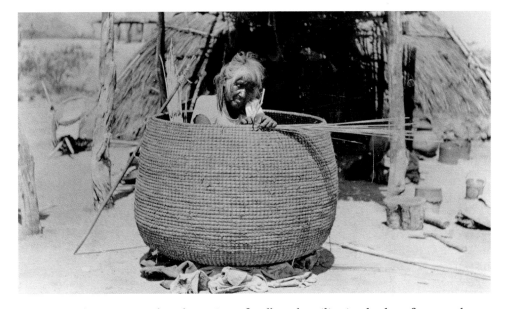

Both groups produced a variety of well-made utilitarian baskets for everyday
household activities. By the twentieth century, some women also were making
finely coiled pieces for the collector's market. Coiled baskets made by both groups
were constructed on a foundation consisting of a fiber bundle of grasses or
cattail stems and sewn with willow and devil's claw splints. Stunning black-and-white
geometric designs and occasional figurative images were characteristic of these
baskets, made in both jar and tray shapes.

During the 1920s, coiled miniature baskets made by both groups were avidly
collected by Mae Heard, co-founder of the Heard Museum, and other Phoenix women.
These miniatures were of two major categories: coiled baskets of willow and
devil's claw that were small replicas of larger baskets, and fanciful renditions of Anglo
domesticity such as tea cups, saucers, cream pitchers, and sugar bowls. A decade later,
some Papago women were making coiled baskets with split willow stitches spaced
to form a design. This style is still made today, with a slight variation in which one or
more long stitches are passed through the splits to make a fancy pattern.

Because the Pimans had easy access to willow, its neutral color tends to
predominate in their baskets. Rims and bases, as well as design accents, were executed

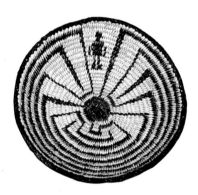

Coiled Tray by Hilda Manuel, Akimel O'odham, 1983. Willow coils, cattail stem foundation, martynia designs. Height, 4.1 cm (1 5/8"); diameter, 15.7 cm (6 5/8"). Collected by Andrew Hunter Whiteford. SAR 1983-17-3. This design is called the man-in-the maze, or Etoi, the elder brother. Although its origin is uncertain, some scholars believe it might derive from Hohokam rock art.

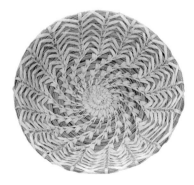

Coiled Tray, Tohono O'odham, about 1965. Photographer unknown
A modern example of the split wheat stitch.

in devil's claw. The Papagos took good advantage of the fact that devil's claw tends to flourish in desert environments and used it rather extensively. During the past two decades, some enterprising women have planted small gardens of devil's claw to use in their own baskets and to trade and sell as an additional source of revenue.

Three additional materials have entered the repertoire. Because willow is so scarce among the Tohono O'odhams, today many women are making attractive yucca baskets. A nonplant material, horsehair, has been used to make baskets since the early twentieth century, and the past twenty years or so have seen a dramatic refinement in the quality of coiled horsehair baskets. Many have been prizewinners at various Indian art shows and markets. The most recent material to be used for basket making is even further removed from Mother Earth. Some unusual baskets made of elaborately worked metal wire have attracted some collectors, and appalled others. In any case, the continuously unfolding theme and variations on creativity have defined the development of twentieth-century Southwestern Indian basketry.

Lessons Learned

"Foundations," the title of this chapter, acts as a metaphor. The word describes the underlying structure of coiled baskets, but it also describes the framework—the history, techniques, and challenges—that confronts basket makers both past and present. During the first session of the convocation, the participants viewed the basketry collection at the IARC. Each discussed one or two historic pieces, representative of his or her tribe. Some of those baskets, and the weavers' comments, are presented in this section.

To paraphrase Keith Basso, wisdom sits in baskets. There is much to be learned from these venerable baskets, especially as interpreted by the convocation participants. Comparisons of construction methods, design composition, and dye materials between "old timer" and modern examples provided provocative insights concerning continuity and change in twentieth-century Southwestern Indian baskets. There also were some surprises. For example, a basket can contain important environmental information. Kevin Navasie speculated that the reason that Jemez basket makers use the whole, unsplit yucca leaf is probably because the

Coiled Tray, Akimel O'odham, about
1920s. Willow coils, cattail stem foun-
dation, martynia. Height, 16.5 cm (6");
diameter, 45.7 cm (18"). IAF B31.
The fret motifs are used to make a
squash blossom, a typical Pima design.
Martynia (devil's claw) is very durable
and is used frequently for the
vulnerable base and rim areas.

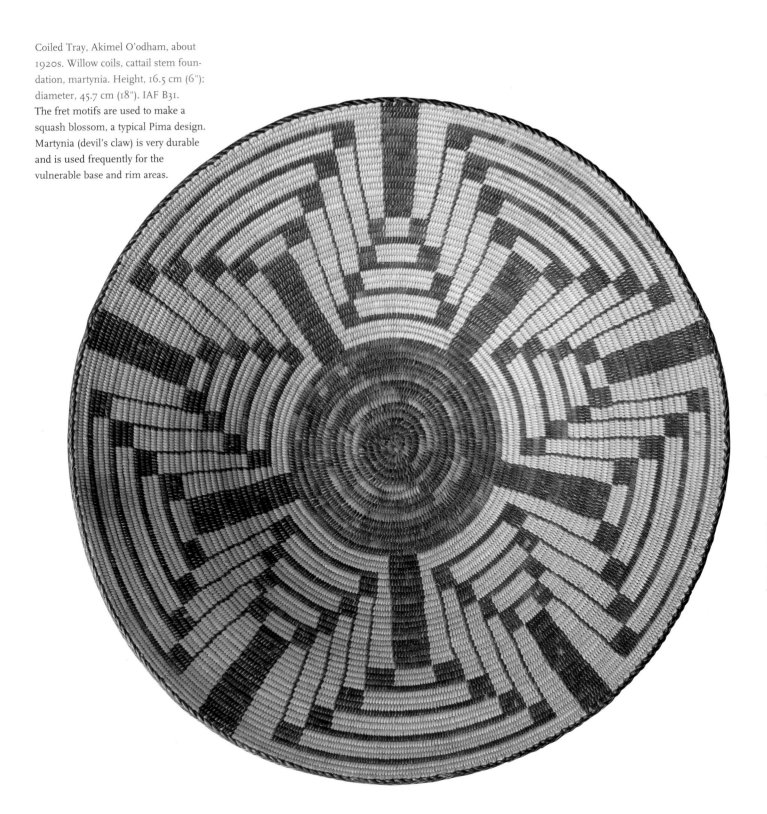

Coiled Tray, Tohono O'odham, date unknown. Willow coils, cattail stem foundation, martynia. Height, 16.2 cm (6 3/8"); diameter, 40.6 cm (16"). IAF B322.

Since martynia is more readily available in the desert environment surrounding their reservation, Tohono O'odham basket makers tend to use it to cover larger design areas than do the Pimas.

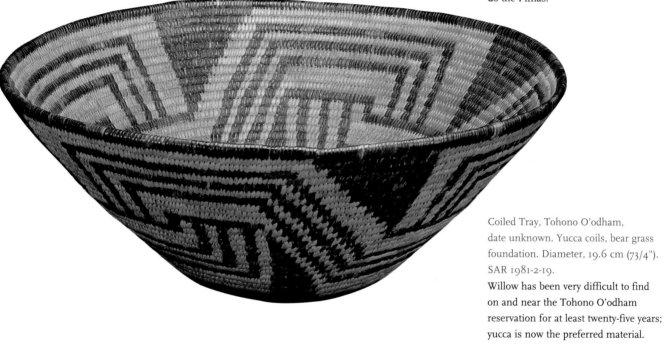

Coiled Tray, Tohono O'odham, date unknown. Yucca coils, bear grass foundation. Diameter, 19.6 cm (73/4"). SAR 1981-2-19.

Willow has been very difficult to find on and near the Tohono O'odham reservation for at least twenty-five years; yucca is now the preferred material.

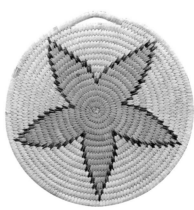

Coiled Tray, Tohono O'odham, about 1965. Horsehair. Height, 0.7 cm (1/4"); diameter, 3.6 cm (1"). SAR 1988-6-108. Horsehair baskets have been popular collectibles since the early twentieth century. Some basket makers suggest that the idea for using the material originated with horsehair bridles, quirts, and other equine accessories made by men in the family.

plants do not grow to be as large around Jemez Pueblo as they do in Hopiland.

Older Tohono O'odham baskets were made with willow splints sewn on a willow-rod foundation, but as Annie Antone explained, the Sonoran Desert does not provide a congenial habitat for willows. Consequently the use of yucca splints over a bear grass foundation has become the norm. Not only are these materials abundant, but according to Antone, they also are easier to harvest and work with.

Baskets can provide clues concerning the lifeways of the groups that make them. Certain designs are associated with specific contexts. Among Second Mesa Hopis, the principal basket made by the bride for the groom always has a star or flower design and is intentionally left unfinished so that the marriage will have the freedom to grow. On Third Mesa the design symbolizes the intimate connection that links the couple. The pathway or break in the design of a Navajo ceremonial basket is associated with healing rituals and emergence, while in Jicarilla baskets it symbolizes the sun ladder of the origin narrative.

Thus baskets themselves have an origin narrative, a chronicle of belief systems, cultural values, environmental impacts, and economic influences. More than the sum of their parts, they are receptacles of human ingenuity and creativity.

The Artists

Ten Basket Makers

The ten artists who participated in the basketry convocation lead lives that are as diverse as their baskets. At the time of the event, they ranged in age from twenty-two to eighty-two. Some live in remote rural areas, others in Pueblo villages or small towns. Some are full-time basket makers; others weave as time permits or when the spirit moves them. Some enjoy building on the design traditions of their ancestors, while others seem to relish the freedom to experiment. But they all share certain common denominators: ethnobotanical expertise, skillful hand-eye coordination, and above all the creative ability to turn plant fibers into works of art. Each basket maker's vision transforms the raw materials into an expression of her or his personality, life experiences, dreams, and aspirations.

Generally speaking, basketry has not received the kind of attention that other Southwestern Indian arts have enjoyed. Pueblo pottery, Navajo textiles, and jewelry made by various tribes all have had greater visibility in the art world. The impressive versatility and virtuosity demonstrated by these ten talented artists should help change this state of affairs. Their baskets are visible, tangible evidence of the different packages that art can come in. Some baskets shout with vibrant colors, others whisper with subtle earth tones. All baskets contain stories to be discovered. Discovery is a journey. As more people take the journey, with baskets as their guide, knowledge and appreciation will surely follow.

Although all the baskets created for the convocation were made using the conventional techniques associated with each tribal group, one unifying concept emerged: tradition is not immutable. It is true that Indian baskets made for sale today are decontextualized from their traditional framework, but commoditization does not diminish their cultural integrity; it simply shifts the emphasis. In the past, baskets made everyday household tasks easier; in the present, the income they produce enhances everyday life. Baskets made for sale are part of today's cultural context, just as baskets made for household use were part of yesterday's. In that sense, today's baskets are still Indian-made for Indian use. And in every sense the basket maker reflects the values and world views of the culture in which she or he lives.

The Artists:
Top row, left to right: Molly Pesata, Rikki Francisco, Joseph Gutierrez, Annie Antone, Sally Black, Kevin Navasie, Lorraine Black. *Seated, left to right*: Abigail Kaursgowva, Remalda Lomayestewa, Mary Holiday Black.

Basket makers work in a unique habitat, one that is grounded in the riches of the natural world and elevated by artistic inspiration. This habitat opens new horizons that define exciting new possibilities. The beautiful baskets produced by the convocation artists have joined other distinguished works of art in the collections of the Indian Arts Research Center at the School of American Research to be enjoyed by scholars, artists, and the general public.

Annie Antone (Tohono O'odham)

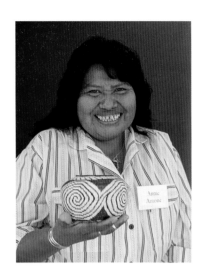

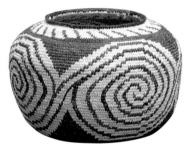

Coiled Jar by Annie Antone, 1997.
Convocation Basket. Yucca coils, yucca
root, bear grass foundation, martynia.
Signed on bottom: "AA". Height, 9 cm
(3 1/2"); diameter, 14 cm (5").
SAR 1997-8-4.
The design was inspired by prehistoric
Hohokam pottery.

Annie Antone learned basket making from her mother when she was about nineteen. A consistent prizewinner at the Santa Fe Indian Market and other prestigious Native American art events, she is widely recognized for her original designs. In 1997 she was invited to London to show her baskets and demonstrate basket making. She won Best of Show at the 1999 Heard Museum Indian Fair for a piece described by a collector as "the most beautiful basket ever made, at any time, in any place, by any person."

"I like to experiment with new ideas that you normally don't see on baskets," Antone says. "I almost always sketch out my designs before begin, even though this is not traditional. My baskets are made from yucca and bear grass. I use devil's claw and yucca root to make the patterns. I sign my baskets on the bottom with my initials, although this is not traditional either. Sometimes I have trouble pricing my baskets because my stuff is so different."

Antone's work is indeed distinctive, characterized by original, sometimes idiosyncratic designs. She has an extremely fertile imagination. Her baskets are defined by invention and surprise and by such fine, tight coiling that, viewed from a distance, their surfaces appear perfectly smooth.

Some of her designs depict the Sonoran Desert landscape of her homeland. Two of the baskets illustrated here exemplify another of Antone's favorite themes: diverse adaptations of prehistoric Hohokam pottery motifs. One of her basketry trays, whose design featured a Gila monster and a scorpion in a desert setting, won a blue ribbon and "Best of Division" award at the Santa Fe Indian Market several years ago.

Like the other convocation participants, Antone spoke at great length about raw materials, for without the Plant People, there would be no baskets. She collects her materials (yucca and bear grass) in June and July and then again in October. But often she collects winter yucca in November, when its color is whitest. Antone occasionally buys her yucca leaves. She uses a bear grass foundation and the white part of the banana yucca (*Yucca baccata*) for her coils, removing the inner "white stuff" from the shaft while the yucca leaf is still wet. Then she lays it out in the sun to dry and bleach for three or four weeks, after which it must be wet again to restore pliability before she can use it.

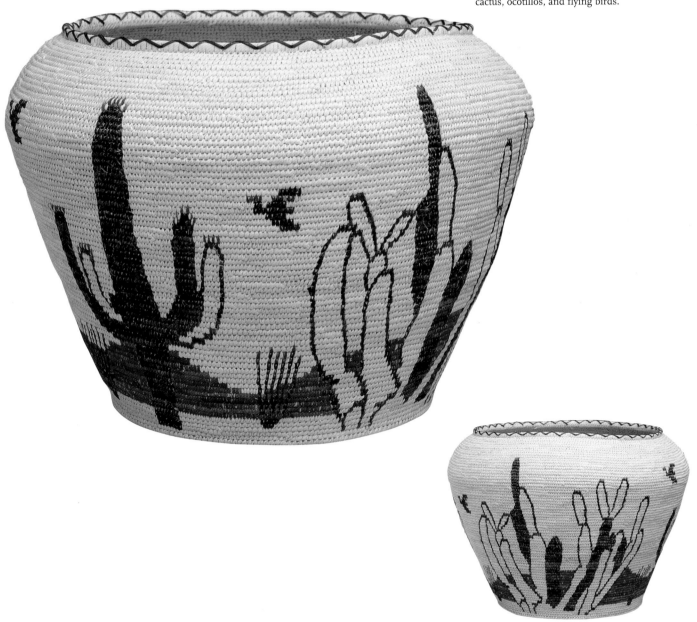

Coiled Jar by Annie Antone, 1997.
Yucca coils, yucca root (reddish brown),
bear grass foundation, martynia.
Height, 23 cm (9"); width, 25.5 cm (10").
Private collection.
This charming Sonoran Desert land-
scape includes saguaro and organ pipe
cactus, ocotillos, and flying birds.

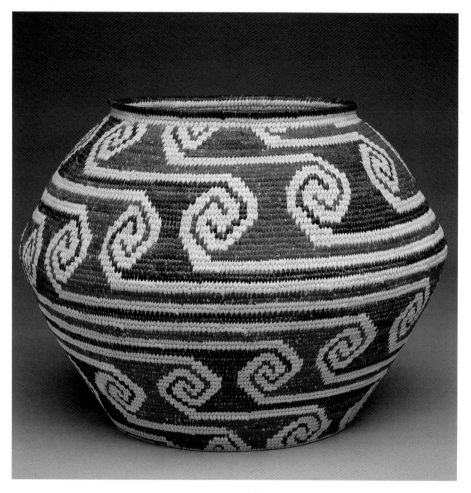

Coiled Jar by Annie Antone, 1995.
Yucca coils, yucca root, bear grass foun-
dation, martynia. Height, 23 cm (9");
width, 25.5 cm (10").
Another example of a Hohokam-
inspired piece. This basket won a prize
for "Most Original Design," a fact
that amused the artist since it was an
ancient Hohokam's original design,
not Antone's.

Antone does not use dyes; all her colors are natural—devil's claw for black and yucca root for red. Her tools are a knife, an awl, and tweezers to help pull the splints out of a small space. Sometimes she flattens out her baskets using a hammer and railroad tie.

Antone signs her baskets with her initials, "A. A."; she was the only artist at the convocation who signs her work. This new development in basket making reflects a growing trend toward name recognition among collectors. In another departure from tradition, she also sketches her designs on graph paper before beginning a basket. I know of only one other instance in which sketches are used to aid design execution, in this case by a Navajo pictorial-weaving family. One basket that Antone seemed especially proud of she called her "Face Basket," a jar shape that featured a very realistic portrait of a man's head. As Antone observed, this was a very unusual design and yet another example of departure from tradition. In fact, it may be said that Antone redefines tradition with every basket she makes.

Mary Holiday Black (Diné)

Mary Holiday Black has been a pivotal influence in the creation of the innovative designs that define contemporary Navajo basketry arts. She has eleven children, nine of whom have become basket makers under her tutelage. Currently she is teaching basket making to yet another generation, a young adopted granddaughter "who could do it all by age four."

Black, whose work is found in numerous museums and private collections, has won many awards. In 1993 she received the Utah Governor's Award in the Arts, and in 1995 she was awarded the prestigious National Heritage Fellowship from the National Endowment for the Arts in recognition of her contributions to the revitalization and advancement of Navajo basketry arts. She was the first Navajo and the first person from Utah to be so honored.

"I made my first baskets when I was nine, and I learned from my grandmother," Black said in Navajo. (She does not speak English, and her comments were translated by her daughter Lorraine.) "When I started, I just made wedding baskets for ceremonies. Then I began to make some other designs. Virginia Smith at Oljato Trading Post was one of the first to encourage me. My basket for the convocation tells a story I learned from my father, who is a medicine man."

Black's ancestral home is on Douglas Mesa, Utah, a remote area adjacent to Monument Valley. Many of her male relatives have been respected ceremonial practitioners, a tradition that has continued to the present day. The women of the family traditionally have tended the sheep, reared the children, supervised the daily domestic routine, and made coiled baskets.

For several years Black made only wedding baskets. Today she occasionally makes baskets for ceremonial use, but her fame is based on her penchant for originality. Even though she is now in her sixties, she remains at the vanguard of innovation. Her large jar forms, featuring figurative designs, combine the difficulty of controlling such a monumental size and shape with the challenge of producing a coherent design statement on such a large surface.

For the most part, the construction of Black's baskets is typically Navajo: sumac splints sewn on a triangular three-rod foundation with a herringbone rim finish. Although today Black uses commercial dyes, a few years ago, in another innovative departure, she experimented

with the kinds of natural dyes that she remembered her mother using for rug weaving. She and a couple of her daughters went on a collecting expedition for the necessary plants and plant products. They processed the materials and made several baskets with them. Unfortunately, the market place did not respond with remuneration sufficiently high to warrant the additional time and labor.

A new design direction taken by Black and several of her daughters is based on traditional Navajo stories. They have been encouraged in this effort by Steve and Barry Simpson, owners of Twin Rocks Trading Post in Bluff, Utah. The designs are adaptations of stories that are told in the winter, stories that have a sacred dimension and reflect the orderly composition of the Navajo universe. The execution of the complex figures featured in story baskets is particularly challenging. These designs can be seen as part of a trend that began with *yé'ii* images (see page 55).

One of the most engaging themes to appear in story baskets is "First Man Placing the Stars," which recounts an incident that occurred after the Diné emerged into this world. First Man decided to brighten the night by placing glowing pieces of mica in the sky. After he had meticulously designed numerous constellations and placed them in an orderly fashion, his work was rudely interrupted by Coyote, the trickster, who stole the bag containing the mica. Coyote then proceeded to find a large red star (some say three red stars) to represent his own glorious self, and randomly scattered the remaining mica into the night sky, thus creating the Milky Way and the haphazard arrangement of other stars.

Black's version of this story is particularly well executed, with tight coils and fluent command of the design elements. This a traditional basket in the sense that it tells a traditional story and is finished in the traditional way with a herringbone selvedge. In another sense it reflects a new direction that moves Navajo basketry designs even farther away from the wedding basket. As a keeper of tradition, Mary Holiday Black still herds the sheep, tells the stories, and weaves the wedding baskets. As an agent of change, she pushes the envelope of design possibilities and encourages others to do likewise.

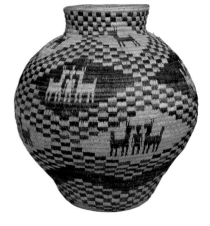

Coiled Jar by Mary Holiday Black, about 1984. Sumac coils and foundation, commercial dyes. Height, 58.5 cm (23"); width, 51 cm (20"). Wheelwright Museum of the American Indian 43/616. Large jar shapes are very difficult to make. This fine example features handsome figurative designs.

Coiled Tray by Mary Holiday Black, 1997. Convocation basket. Sumac coils and foundation, commercial dyes. Height, 5.5 cm (2 1/4"); diameter, 50 cm (19 3/4"). SAR 1997-8-1.

The design in this story basket represents the tale of "Placing the Stars." First Man (in the white, or day) is carefully arranging the constellations. Coyote (in the black, or night) becomes impatient with the laborious task and proceeds to scatter the rest, making sure that his red coyote star is in a prominent place.

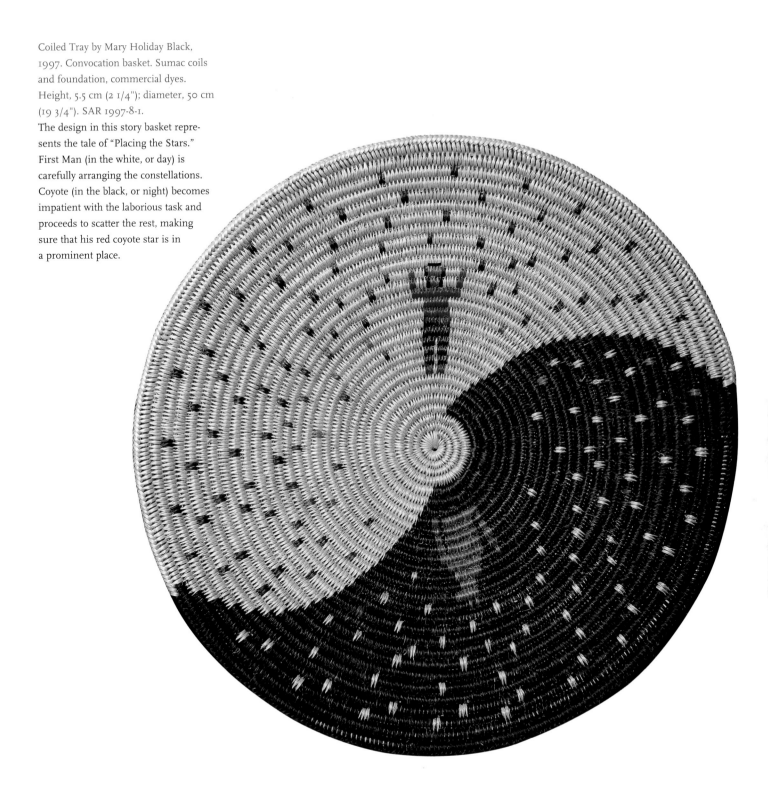

Sally Black (Diné)

Coiled Tray by Sally Black, 1990. Sumac coils and foundation, commercial dyes. Height, 3 cm (1 1/4"); diameter, 52.8 cm (20 3/4"). Wheelwright Museum of the American Indian 43/614.
The figurative designs on this basket were inspired by photographs of Western Apache pictorial baskets from the Foutz collection.

Mary Holiday Black's eldest daughter is a celebrated basket maker in her own right. During the late 1970s, she began to depict *yé'ii* and *yé'ii bicheii* images in her baskets. The *yé'iis* are a special class of sacred personages. The *yé'ii bicheiis* are masked impersonators who appear in certain ceremonies. Although they are borrowed from Navajo ceremonial practices, these images have no specific ritual significance when they are created as secular art forms. Since her teenage years, Sally Black has won many awards and is widely recognized for her original designs. She and her sister Agnes, who also is a basket maker, have an elegant *hooghan* (traditional dwelling) across from the entrance to Monument Valley. Many visitors stop by to watch them make baskets.

"I learned to make baskets when I was nine by carefully watching my mother," Black says. "I started using *yé'ii* and *yé'ii bicheii* designs because my mother used to weave them in her rugs. And when the *yé'ii bicheiis* come during a ceremony, they give you a blessing. I like making baskets. I like to see how the designs I think about come out. I am teaching my sons to make baskets too. But right now it's more important that they do their school work."

Black's pictorial baskets are avidly sought after by private collectors and museums throughout the Southwest. The *yé'ii* basket that she made for the convocation took her more than a month to make. The pink color of the apparel worn by one of the *yé'ii* figures is from dye made from holly berries collected near the Indian Arts Research Center at the School.

The *yé'ii* design represents Black's first departure from tradition. Serious objections were raised by conservative Navajos when these sacred figures were first decontextualized to be woven into rug designs. Although these caveats exist today among the more orthodox, gradually market appeal and increased secularization influenced the acceptance of *yé'ii* and *yé'ii bicheii* rugs as a popular art form. Similarly, the first use of such designs in Black's coiled basketry trays, which are so closely associated with ritual practices, provoked criticism from religious conservatives in Black's family and from other medicine men as well. But Black's desire to create original compositions, compounded by a receptive market, ultimately prevailed.

Coiled Tray by Sally Black, 1997. Convocation basket. Sumac coils and foundation, commercial dyes. Height, 8.5 cm (3 1/4"); diameter, 50 cm (19 3/4"). SAR 1997-8-7. Depictions of *ye'ii* figures first appeared on Navajo textiles in the late nineteenth century. *Ye'ii* rugs woven by Sally Black's mother, Mary Holiday Black, inspired Sally to use the design in her baskets.

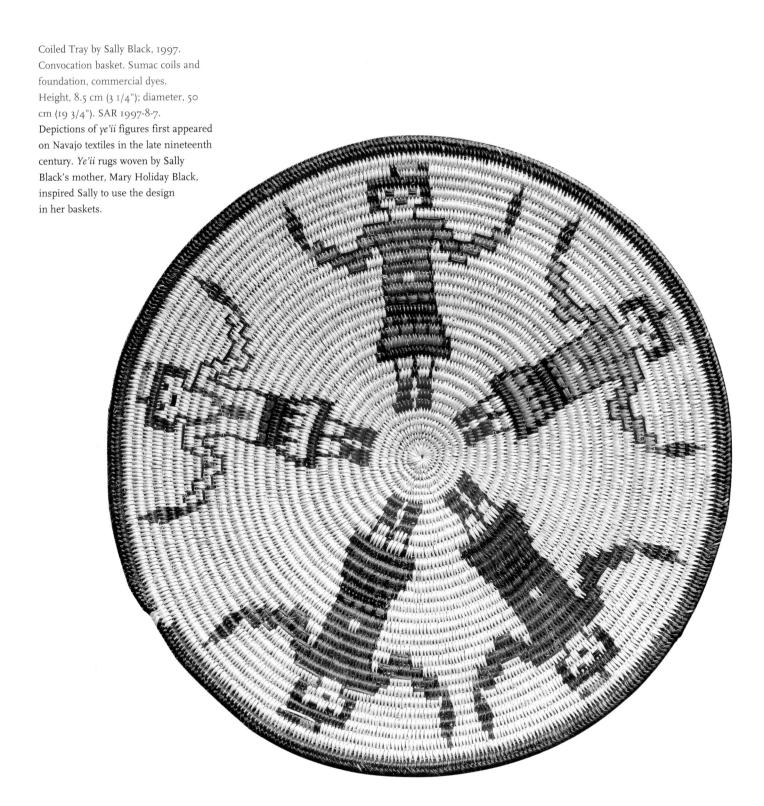

Sally Black

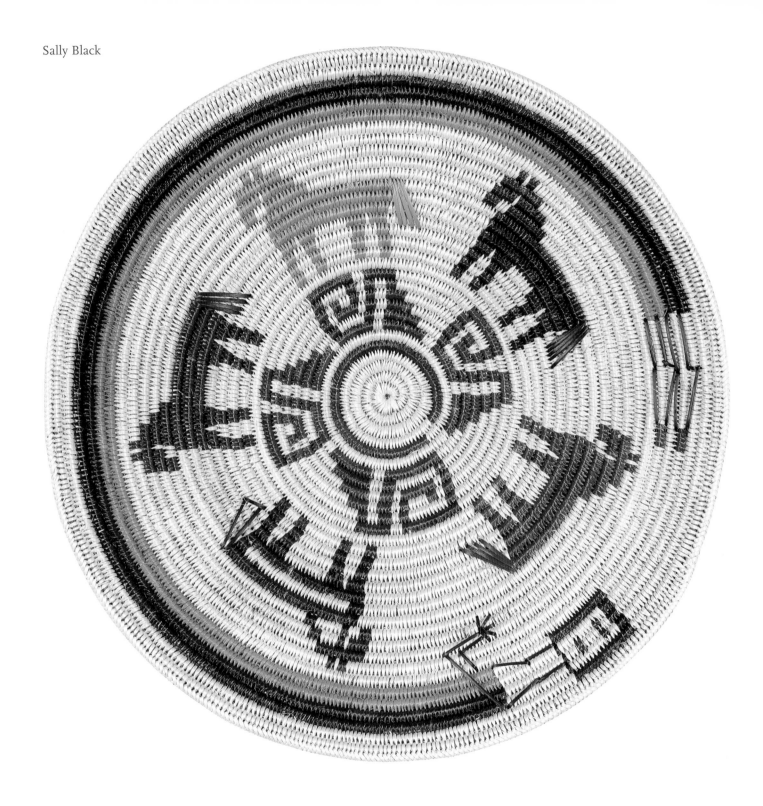

Black believes that these sacred beings are fundamentally beneficent and that replicating them should not be harmful. Nonetheless, she frequently has a ceremony performed to protect her from any possible adverse effects. Other basket makers also have had success with yé'ii designs. Some may have been influenced by Black's work, but others may have initiated the design independently. Today, many Navajos consider ceremonial themes removed from sacred context to be acceptable subjects for secular art.

During the 1970s, trader Russell Foutz gave the Black family photographs of his mother's collection of historic baskets. The influence of Western Apache designs can be seen in the images of animals and people that soon emerged in their work (see pages 52 and 54), but the construction of the basket and the use of three-lobed sumac are fundamentally Navajo. The selective borrowing of ideas and technologies from other groups has been typical of Navajo culture throughout its history, but in almost every instance the borrowed trait has been translated into a distinctively Navajo idiom.

In recent years, Black has on occasion applied an overlay stitch to emphasize certain details of costume or body, another new idea from the fertile mind of the basket maker. Her latest design direction is the creation of story baskets. Story baskets encode the moral messages implicit in the Navajo narrative tradition. Their iconography is not only visually potent, it also is metaphorically evocative. One of Black's favorite themes is the "Sun's Horses." One version (not illustrated) contains yet another innovation: Black wove in real horsehair for the horses' tails.

Lorraine Black (Diné)

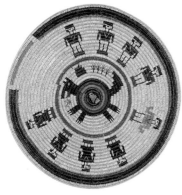

Coiled Tray by Lorraine Black, 1996.
Sumac coils and foundation,
commercial dyes. Height, 3.5 cm
(1 1/4"); diameter, 45.5 cm (17 3/4").
Private collection.
The design depicts a storyteller inside
the *hooghan* relating the story of the
horned toad to his family. This lizard,
a common denizen of the Southwest, is
sacred to the Navajos and plays a
frequent role in many ceremonial
narratives.

Lorraine Black is another of Mary Holiday Black's talented daughters. Like other members of her family, she has recently begun to experiment with pictorial motifs based on traditional Navajo ceremonial stories.

"I made my first basket for a teacher at my school," she recalls. "She was getting married and needed a wedding basket. Then I made a big one and sold it to a gallery in Kayenta. I was only fourteen and so I gave the money to my mother. Like car makers come up with new designs all the time, so does my family. Even though I am married, I use the name Black because it's so famous—especially since my mother won her big award."

Although she is best known for her pictorial baskets, Black chose to make a traditional wedding basket design for the convocation. It is sewn with sumac coils over a sumac three-rod foundation and is finished with a herringbone selvedge. The pattern features stepped-terraced triangles, representing clouds and mountains, separated by an encircling red band that represents a rainbow. In typical Navajo fashion, the ceremonial break aligns with the small ridge that characterizes the end of the last coil.

Since the IARC did not have a modern example of this classic Navajo basket, it was a welcome addition to the collections. Black's basket also serves as a reminder that today two types of coiled basketry trays are made: the wedding basket continues to be produced for ritual use, thus confirming the vitality of Navajo ceremonialism, while the secularized version of the basket provides a vehicle for creative growth.

Black's dedication to exploring new design ideas is exemplified by her horned toad basket. The horned toad, cleverly made of stone, has a place of honor in the center of the basket. Navajo storytellers relate that horned toad is a guardian being to the Diné. When a Navajo needs protection, the lizard is able to create arrowheads made out of stone. Black has a number of design variations based on this story, some of which include stone arrowheads as well as the stone horned toad.

Another source of inspiration for Black's baskets are Navajo rug designs, such as the "storm" pattern that probably originated in the western reservation area. Black also has become intrigued with the design potential offered by the computer at Twin Rocks

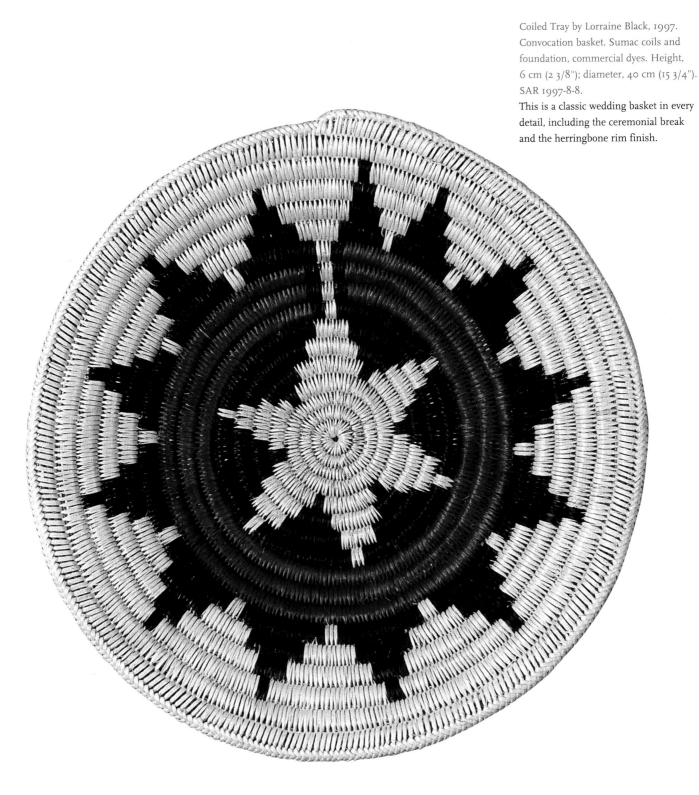

Coiled Tray by Lorraine Black, 1997.
Convocation basket. Sumac coils and
foundation, commercial dyes. Height,
6 cm (2 3/8"); diameter, 40 cm (15 3/4").
SAR 1997-8-8.
This is a classic wedding basket in every
detail, including the ceremonial break
and the herringbone rim finish.

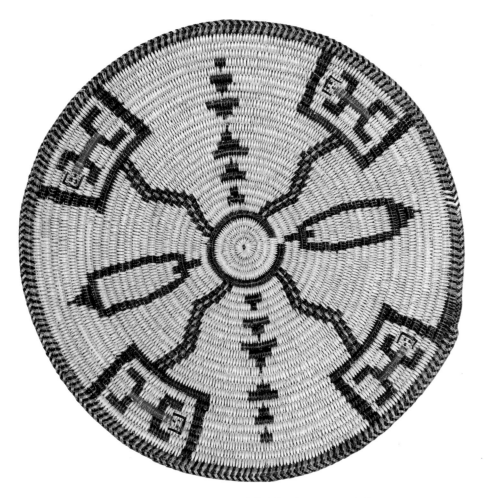

Coiled Tray by Lorraine Black, 1995. Height, 3 cm (1 1/4"); diameter, 38 cm (15"). Sumac coils and foundation, commercial dyes. Private collection. Black has interpolated a popular rug design, the storm pattern, into her basket. The pattern features lightening bolts that emanate from the four sacred mountains, each with its in-dwelling spirit.

Trading Post in Bluff, Utah. With the help of a Navajo painter, Black and several of her sisters are creating original images on the "Mac" that subsequently are transformed into basket designs. This is taking Annie Antone's use of sketches on graph paper another high-tech step farther.

Black said that her family collects sumac in late October and early November, often traveling considerable distances beyond the reservation to find a sufficient supply. They scout along rivers and creeks between Moab, Utah, and Grand Junction, Colorado, using a knife or pruning shears to gather the material. The gathering process takes several days, as they must collect two or three truckloads at a time, enough to last a year. They make sure to trim only a little from each bush to ensure that more will grow in the spring. "The plant is the basket, and the basket is the plant," Black says, thus recognizing that the correlation between basket maker and plant is an integral component of the creative process. Basket makers are by definition earthy people.

Rikki Francisco (Akimel O'odham)

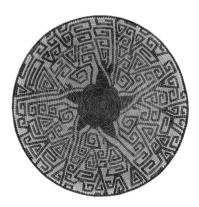

Coiled Tray by Rikki Francisco, about 1980. Height, 2.5 cm (1"); diameter, 28.5 cm (11 1/4"). Private collection. The artist initially was reluctant to make this basket because the design was so complex. It is based on a design from Sacaton, the Akimel O'odham village where Francisco lives.

Rikki Francisco's Indian name translates as "Whirlwind." A fourth-generation basket maker, she is the only one among her seven sisters to carry on the tradition. She has won many awards and is widely recognized as one of the outstanding basket makers of her generation. She also is well known as a teacher, generous in sharing her knowledge with aspiring young basket makers as well as with collectors and others interested in baskets and basket making. Francisco is a forceful individualist who actively promotes her native language.

"My people always start their baskets with a black [martynia] center because it's sturdier," she says. "I am a traditional basket maker, but I also like to try new designs. I always finish my basket with the same rim stitch [herringbone], because that's the old style. Sometimes I polish my baskets with a river stone, and I think this is an original idea. I went to college, but I didn't want to be in the job world, so I went back to the earth where I belong."

Francisco's work is modern by tradition. Although she occasionally will explore new ideas, she prefers making "old style" baskets. "I need to balance the modern with the traditional," she explains. The basket she made for the convocation is based on a traditional water design that was almost certainly influenced by her tribe's location on the Gila and Salt Rivers. Water has always played a critical role in the survival of Southwestern Indian peoples. Those groups that lived on or near water sources had a marginally easier life than those inhabiting more arid regions. Farming was more productive, and wild plants grew in greater profusion as well, including the river willows used to make the sewing splints and the cattail stems used to make the bundle foundations of Akimel O'odham baskets. After Roosevelt Dam was built, however, the Gila River dried up and many willows died. At that time, Francisco said, many Akimel O'odhams stopped making baskets.

Francisco gathers willow from May through September and cattails when the "cat" turns brown, usually in June and July. She cuts the tails off the plant and hangs them to dry before she splits them. The black color comes from the "claw" of the martynia plant. She soaks the material first, then splits it the same way she does the willow by using a perforated lid to make thin strands. The red dye is made from cooking the

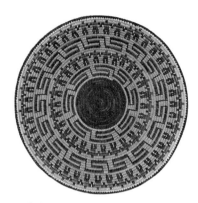

Coiled Tray by Rikki Francisco, about 1980. Height, 2.5 cm (1"); diameter, 30.5 cm (12"). Private collection. The image on this "friendship" basket is influenced by an indigenous California (Yokuts) design.

roots of the mountain mahogany bush. Francisco says she remembers her ancestors when she's gathering, processing, and weaving. She recalls the days when her great-grandmother, grandmother, and mother sat in a circle under a large tarp making baskets. "And when I'm gathering willows, when I go out gathering, they are with me."

As Andrew Hunter Whiteford observed in 1988, "At one time both the Pimas [Akimel O'odhams] and the Papagos [Tohono O'odhams] made very fine coiled baskets, but in recent years, Pima basket making has almost disappeared, except for the work of a few women." Rikki Francisco is one of those women. Her coiled baskets are as fine as any Akimel O'odham basket made in the past. Her technique is flawless: willow coils tightly sewn over a cattail stem foundation. Her beautifully fashioned small baskets illustrate her meticulous control and precise workmanship.

In order to make one of these small baskets, Francisco must split her material twice and then shave it to make it thinner. She accomplishes this by passing the strand through a lid perforated with graduated holes. Preparing materials for a small basket thus takes more time than for a large one. Francisco occasionally makes a superbly crafted basket on a slightly larger scale, especially if it is a special commission. She also will sometimes improvise on themes that do not originate with her people. Her dedication to excellence ensures that each basket, regardless of its size and style, is a masterpiece.

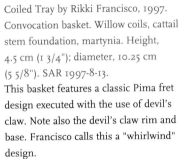

Coiled Tray by Rikki Francisco, 1997. Convocation basket. Willow coils, cattail stem foundation, martynia. Height, 4.5 cm (1 3/4"); diameter, 10.25 cm (5 5/8"). SAR 1997-8-13. This basket features a classic Pima fret design executed with the use of devil's claw. Note also the devil's claw rim and base. Francisco calls this a "whirlwind" design.

Joseph Gutierrez (Santa Clara Pueblo)

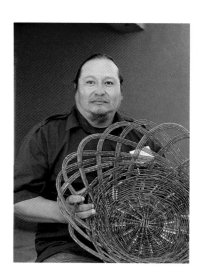

Joseph Gutierrez's handsome red-willow baskets are in demand in his village for everyday household tasks and for use in Basket Dances as well. A highly respected teacher, he is dedicated to passing down his knowledge as a way of honoring his mentor, Steven Trujillo, a well-known maker of red-willow baskets from San Juan Pueblo.

"I learned to make red-willow baskets in 1974 while I was still in high school," Gutierrez says. "Before he died, my teacher asked me to keep it up for him, and so I teach basket making at the Poeh Center [at Pojoaque Pueblo]. People in the pueblos use these baskets for carrying, storing, and serving food, and especially for carrying bread to the kiva on feast days. They also are used in Basket Dances because the plants are from our river."

Gutierrez's female relatives like to use his red-willow baskets for Santa Clara Pueblo's annual Basket Dance, held in February. Gutierrez reiterated that this is because the materials are gathered from the Rio Grande ("our river"), conferring on the red-willow basket the status of "traditional." Traditional in this case is a relative term, for red-willow baskets have been documented in the Rio Grande Pueblos only since the early twentieth century. The style may have originated in Europe, but the technique is so universal that the Pueblos may have re-invented the style for themselves or replicated it from local Hispanic examples. In any case, it seems that for Pueblo people it is the plant and not the pedigree of the basket style that is of primary importance. Santa Clara Pueblo is renowned for its stunning pottery, but clearly red-willow baskets have an important role to play in both domestic and ceremonial life.

Gutierrez typically spends a day processing his materials and then another four to five hours making each basket. He works from October through March and gathers his willow as he needs it. Gutierrez's baskets are sturdy vessels produced with a plaiting method. Because the baskets are plaited with rigid elements, they often are referred to as wickerwork. The shoots of the willow frequently are used with the dark red bark left on; color shifts are accomplished by alternating them with peeled white willow osiers.

The construction of these baskets appears deceptively simple but in fact is quite complicated. They are built of

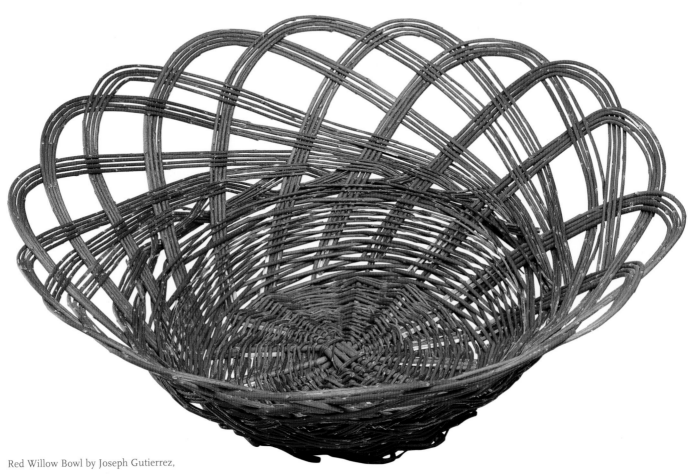

Red Willow Bowl by Joseph Gutierrez, 1997. Convocation basket. Height, 22.5 cm (8 3/4"); diameter, 58 cm (22 7/8"). SAR 1997-8-6. Wicker baskets like this are used both for everyday household tasks and to carry food to the kiva on feast days. They are particularly valued for use in Basket Dances because the plants come from the Rio Grande.

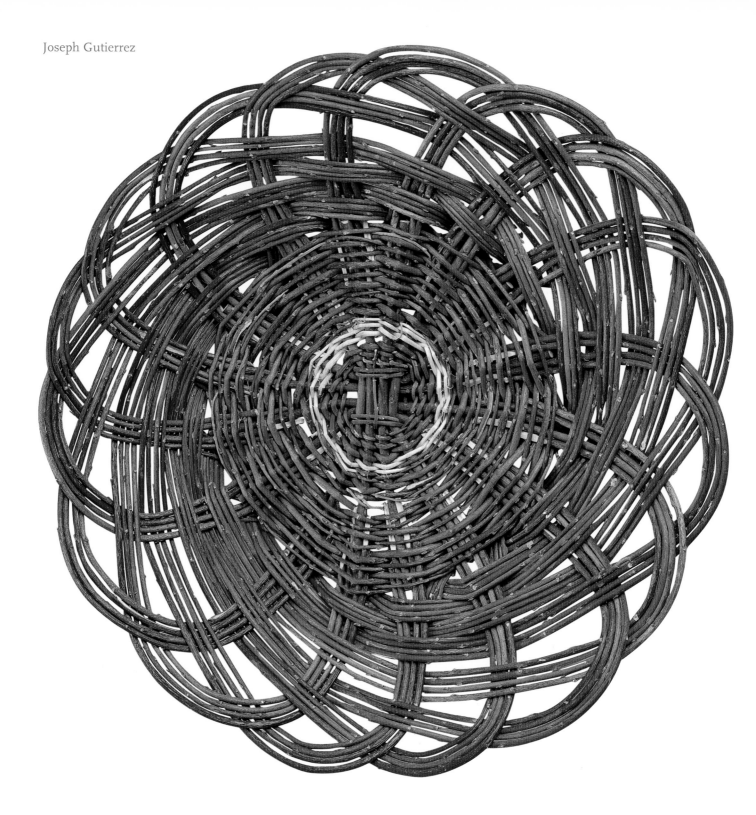

three sections, which are deftly joined together. The start is made with two heavy willow rods that are crossed and lashed together. The ends are separated, and groups of willow wefts are plaited over and under them. The middle part of the basket is often made with diagonal plaiting (two or more weft strands) in a contrasting light color. Finally, to finish the rim, Gutierrez brings the bunched warps to the outside of the basket and works them into a braid that cleverly fastens all the loose ends together with a decorative flourish.

Red Willow Bowls by Joseph Gutierrez. Collection of the artist.
Gutierrez commented that many Pueblo people like to hang red willow baskets on the wall for decoration.

Abigail Kaursgowva (Third Mesa Hopi)

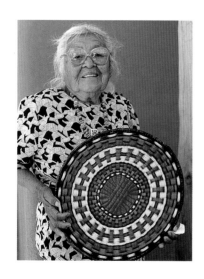

Plaited Wicker Plaque by Abigail Kaursgowva, 1997. Convocation basket. Rabbit brush weft and dune broom (?) warp, commercial dyes. Height, 3 cm (1 1/4"); diameter, 32.5 cm (12 5/8"). SAR 1997-8-9.
This interesting design is based on a Hopi "maiden's shawl" embroidery pattern.

Born in the village of Hot'vela on Third Mesa in 1915, Abigail Kaursgowva was the most senior participant in the SAR convocation. Like many Hopi girls of her generation, she went away to school and returned to Hopi when she was sixteen. When she was eighteen, she learned basket making from her mother, a very fine basket weaver. Her father made burden baskets.

Although her mother made deep basketry jars, Kaursgowva is known for her plaques featuring bold, colorful, geometric designs, and she often comes up with new ideas. She demonstrates basket making at various museums and has won numerous awards. Three generations of her family often get together to make baskets (see page 71).

"The women from my mesa make wicker baskets," Kaursgowva says. "My mother used plant dyes, and sometimes so do I, but that's a lot of work and so I use store colors most of the time. When I make my katsina basket figures, I do them in two pieces. Mostly I sell my baskets to white people who come around the village wanting to buy them. I find it very interesting that all these (non-Hopi) Indians are all making baskets and they are all different."

As in the case of the red-willow baskets from the Rio Grande Pueblos, wickerwork is a descriptive rather than a technological term. Kaursgowva's baskets are plaited, made with supple weft stems of rabbit brush passed over and under warps of *siwi* (*Parryella filifolia*, sometimes called dune broom). This style of wicker basket is unique to Hopi Third Mesa; it is not made in other Hopi villages, nor is it found among any other Southwestern Indian group. Just how, when, and why this distinctive style developed on Third Mesa has yet to be determined.

With their explosion of dazzling colors, Kaursgowva's plaques resemble a fragmented rainbow. She brought three baskets to the SAR convocation. The design of one is based on the embroidered border of a Hopi maiden's shawl. Another is the wedding plaque that the bride gives to the groom, filled with white cornmeal. The design symbolizes the close relationship of the married couple. The third plaque is in fact two plaques in one, a cunningly devised flat katsina doll.

Kaursgowva demonstrated how she uses a board to hold the warp and weft materials in place when she is starting a basket. She is one of the few women who

Plaited Wicker Plaque by Abigail
Kaursgowva, 1997. Convocation basket.
Rabbit brush weft and dune broom (?)
warp, commercial dyes. Height, 4 cm
(1 3/4"); diameter, 40.5 cm (16").
SAR 1997-8-10.
The design on this colorful plaque
indicates that it is a wedding basket,
given by the bride to the groom as part
of the wedding payback. The band
of blue rectangles connected by a
black and orange circle symbolizes
the ties that bind the
couple together.

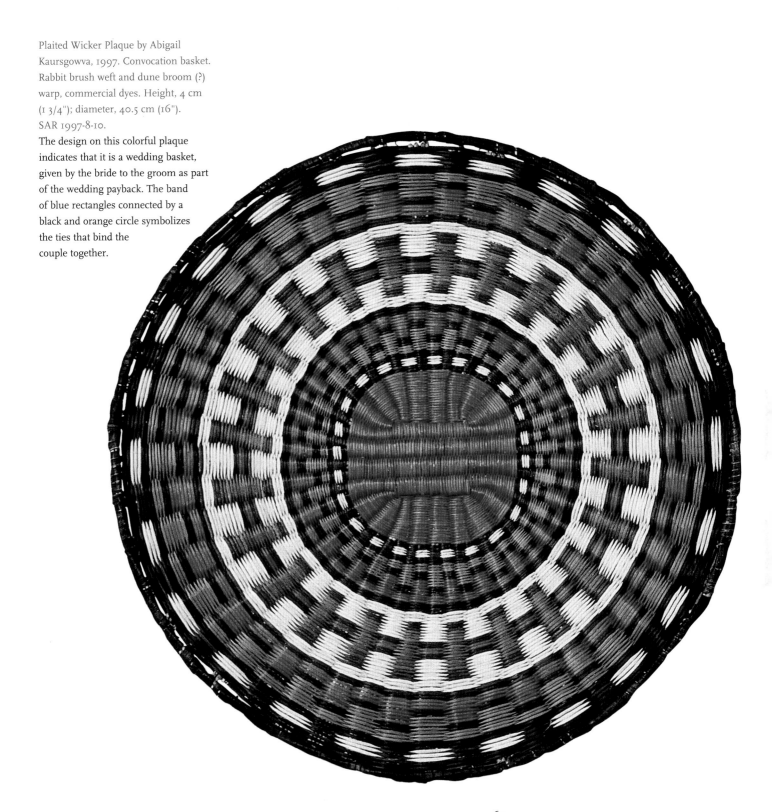

Abigail Kaursgowva

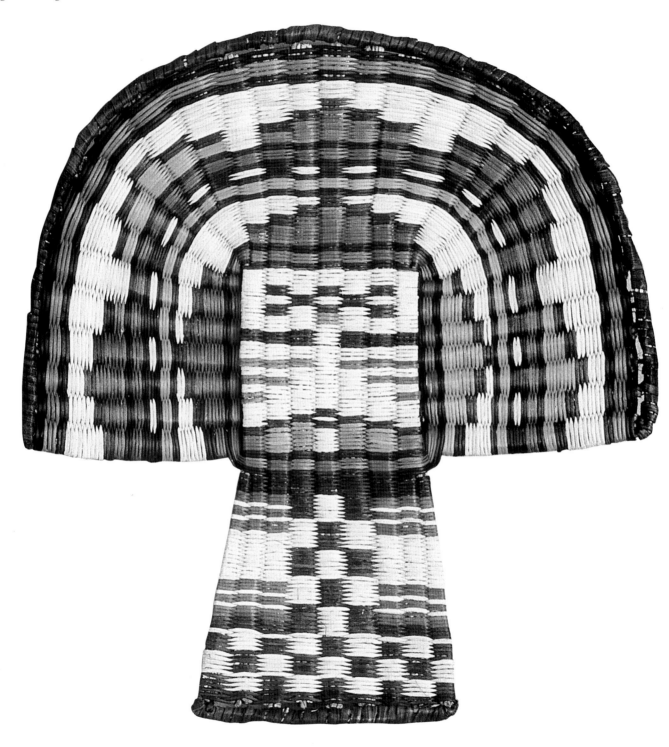

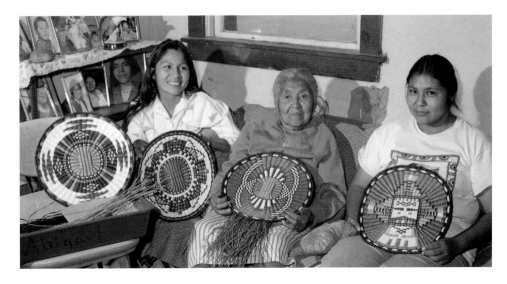

Abigail Kaursgowva with her grand-daughters, Jolene Lomayaktewa (left) and Harriet Lomatska, holding examples of their excellent plaited wicker baskets, 1991.
Photo by Helga Teiwes.

<

Plaited Wicker Plaque by Abigail Kaursgowva, 1997. Convocation basket. Rabbit brush weft, dune broom (?) warp, commercial dyes. Height, 3 cm (1 1/4"); width, 30.5 cm (12"). SAR 1997-8-11.
This clever plaque, in the shape of a flat Palhik'mana katsina doll, is made in two pieces that fit together in the back.

remembers how to make the diagonal or stepped start that was common at the turn of the twentieth century, a technique she learned from her mother; see page 23. For reasons that are not clear, this start fell into disuse about 1930 and is seldom used today. To make a wide basket, Kaursgowva uses up to four warp sticks bound together with the weft strands.

Kaursgowva also talked about the plant dyes that she learned how to make from her mother and still uses occasion-ally. Red is made from Mormon tea smoked over a fire fueled with sheepskin; blue is made from indigo dye; green is achieved by combining indigo with the yellow blooms of the chamisa bush; black is made from sunflower seeds. To enhance natural white, kaolin clay is frequently used. (Kaolin also is used to enhance the white color of moccasins

and wedding robes.) Kaursgowva reiterated that, although she is capable of making and using these plant dyes, she prefers the easier method and brighter colors made possible by aniline dyes.

As Helga Teiwes wrote in 1996, "Abigail does not waste any of her dyed [material], inventing and creating her own colorful designs. Her weaving creates an impression of kaleidoscopic geometric designs." Visitors to Hot'vela frequently ask where they can find a good basket maker. If they are fortunate enough to be directed to Kaursgowva's house, they will enjoy her vivacious personality as well as her vibrantly colored baskets.

Remalda Lomayestewa (Second Mesa Hopi)

Like many basket weavers, Remalda Lomayestewa learned the art from her mother and grandmother and produced her first basket when she was twelve. She explained that although young girls can help gather and process materials, they cannot make a basket until they have been initiated. Today Lomayestewa is recognized as an excellent weaver of coiled baskets, which she makes for paybacks, gifts, and Basket Dances. If she has additional time, she also makes baskets for sale.

"I think about what kind of design I want and picture how it will look," she says. "I make all kinds of designs, but mainly I like *katsinam*. The design is all in my head. It takes me two or three months to make an ordinary basket, but a lot longer to make a really big one. Every basket I make has a purpose and tells a story."

The Hopi landscape is a rugged panorama of mesas, canyons, and high desert. Survival in this arid land has always been a struggle. The *katsinam* visit Hopi villages during seven months of the year to confer blessings and to bring the desperately needed moisture in the form of snow and rain. It is no wonder, then, that these spirit beings are so frequently the subject of basketry designs. Other life-giving symbols also are popular, such as clouds, corn, and especially turtles, because of their association with water.

Lomayestewa explained that when turtles are killed to make the ceremonial rattles worn by the *katsinam*, it is hoped that the rattles also will bring rain. Like the rattles, a turtle basket represents the survival of the Hopi people. In Lomayestewa's hands, the turtle basket also is an appealing, colorful work of art. For the basket she made for the convocation, she surrounded the turtle with "rain clouds, Big Thunder, and the coming of a storm." The basket took her two months to make.

Lomayestewa is from the Second Mesa village of Songoopovi, whose women are particularly known for their coiled baskets. They make their coils from thin yucca splints sewn over a foundation of galleta grass or rabbit brush. Lomayestewa prefers the rabbit brush. She often uses aniline dyes for black and red, but otherwise all her colors are natural. She recalls that in "the old times" black was made from sunflower seeds, but since this produces a kind of muddy-gray color, she prefers a commercial black dye. Her white color is achieved

Coiled Plaque by Remalda Lomayestewa, 1997. Convocation basket. Yucca coils, galleta grass foundation, commercial dyes. Height, 4.75 cm (1 7/8"); diameter, 31 cm (12 1/4"). SAR 1997-8-12. The raised turtle's back is pushed out from behind. The turtle, a Hopi symbol of rain, is surrounded by rain clouds and Big Thunder.

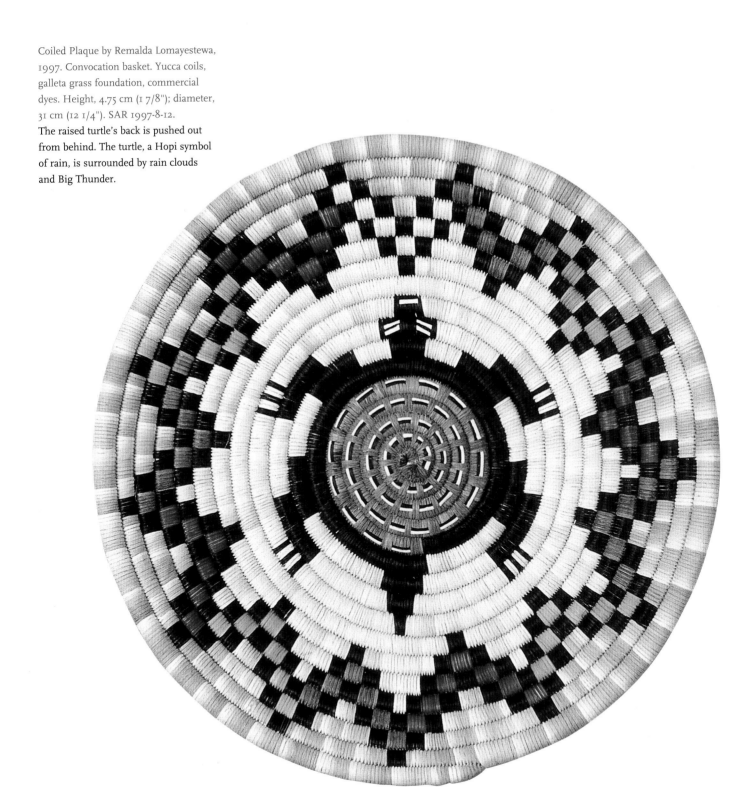

Remalda Lomayestewa

Remalda Lomayestewa with large coiled jar in progress, 1991. Photo by Helga Teiwes. Lomayestewa occasionally makes very large jar shapes. She recalls that her grandmother once made a basket so large that the door of her house had to be removed in order to take it out.

by bleaching the yucca and sometimes also by rubbing it with kaolin clay.

Lomayestewa gathers her yucca in August because that is when the plant is the whitest. Yucca for yellow is picked in February or March. Sometimes she uses a knife to cut the leaves, but she prefers to use pruning shears. When she gathers her yucca, she spends all day in the field since she only picks four or five leaves from each plant. The gathering location is often many miles away. She and a couple of friends, also basket makers, will drive there in one car. She observed that other Native Americans sometimes feel the Hopis are trespassing on their land when she and her friends gather there. She occasionally will trade *piiki* bread for permission to gather plants.

When she returns home, Lomayestewa splits the material until the leaf is a fine flat fiber; this process takes an additional two or three days. Then the splints are laid out in the sun for bleaching. It is important that the yucca not be exposed to rain, or it will bleach too fast. When these preparations are complete, Lomayestewa goes out in the field and picks more yucca. This cycle is repeated four or five times, since she must collect enough to last a year. After all the material has been processed, it is tied in a bundle to store for future use. When she is ready to make a basket, she must soak the material in order to restore its flexibility. The start of her baskets is made of the fine yucca "side hairs" that are discarded during the splitting process.

Lomayestewa is deeply involved with all aspects of Hopi life. She is keenly aware that to be a Hopi woman is to be a busy woman. Since basket making is integral to the role, she is deeply committed to creating baskets, and creating them beautifully.

Plaited Sifter Basket by Kevin Navasie,
1997. Height, 7 cm (2 3/4"); diameter,
31 cm (12 1/4"). SAR 1997-8-3.

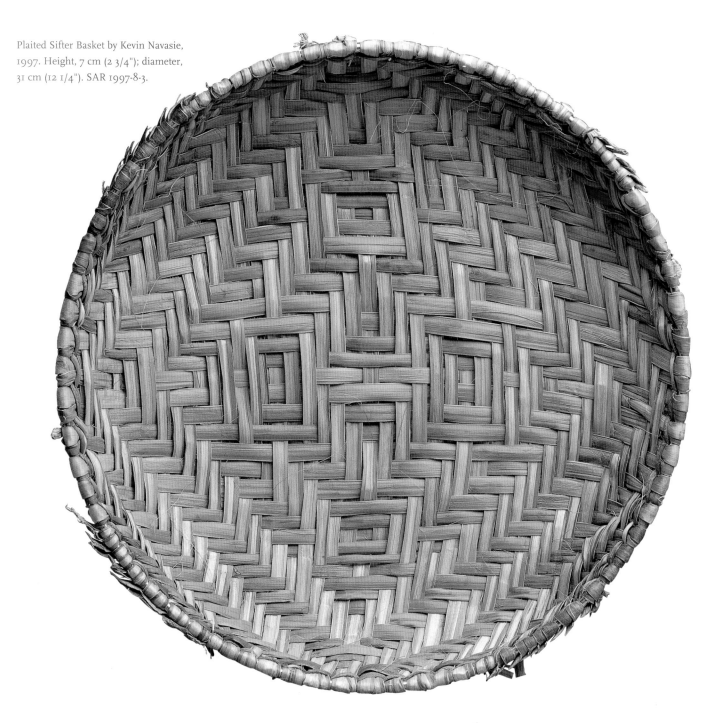

Kevin Navasie (First Mesa Hopi-Tewa)

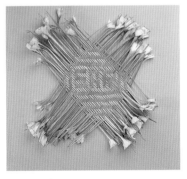

Plaited Sifter Basket, mat in progress, by Kevin Navasie, 1997. Convocation basket. Yucca. Height, 26 cm (10 1/4"); width, 43 cm (17"). SAR 1997-8-2B. This unfinished basket is a good example of Navasie's use of innovative designs. He has placed the initials "SAR" in the center to honor the institution.

Kevin Navasie, the youngest participant in the convocation, was a student at the Institute of American Indian Arts at the time of the gathering. During the summer of 1997 he was the Dubin Fellow at the School of American Research, an award given to outstanding Indian artists. He also served as the principal facilitator for the convocation.

When Navasie is at home in Hopiland, he gives some of his baskets away to relatives and friends who need them for paybacks. Sometimes he trades them for food, as well. He observed that very few people keep up the tradition of trading within the community.

"I make sifter baskets, also known as yucca ring baskets," Navasie says. "These are made on all three mesas. They are used for holding and storing food, as colanders for washing corn and beans, as part of the Basket Dance, and for wedding paybacks. The 'elderlies' say that the outer side of the basket is the universe and the inside keeps us all together."

Navasie is particularly known for using letters and pictorial images in his sifter baskets. This is a major innovation, since these containers are utilitarian wares that usually have only geometric designs. The different colors in Navasie's baskets are achieved by bleaching the yucca leaves in the sun for different amounts of time. The color also depends upon what time of year the plant is collected and which part of the leaf is used. However, Navasie observed, "There is a time when we don't collect materials, when we let the earth and everything rest."

A sifter basket begins life as a plaited mat that is then passed over a wooden ring and sewn down on the ends. Navasie explained that the ends of the yucca strands that stick out before they are sewn down represent the sun's rays. He uses red willow, white willow, or three-lobed sumac for his rings and usually collects "a whole bunch" at a time. "Today many basket makers go to the store and buy metal hoops, but baskets made with steel rings cannot be used for ceremonies or in Basket Dances," he noted. After Navasie collects the wood for a ring, he ties it into a circle with wire, duct tape, or masking tape. Then the ring is tied with a yucca strip so it can be stored for future use. Navasie prepares several rings of varying sizes, so that he can choose what size basket he wants to make.

He also uses awls of different sizes to split the yucca. All parts of the yucca are used; nothing is wasted. For example, shreds left over from splitting are given to basket makers on Second Mesa to use in the foundations of coiled baskets. Small pieces are given to pottery makers to fashion into paintbrushes. The bottom part of the plant is used as a shampoo.

Before he begins a basket, Navasie sorts the yucca splints according to size, with the longer pieces in the middle. This is accomplished by grabbing a bundle of splints and shaking it; the shorter pieces fall out and the remaining pieces are all the same size. This process is repeated for each size until all the yucca has been sorted. Then the tips are cut off with a scissors. The next step is to divide the bundle with the longest pieces in half, using an equal number of strands from each half to make the middle diamond design. This central image is called the "eye of the basket."

Since Navasie likes to experiment with different designs, he often starts off with an odd number of splints: fifteen or seventeen green ones, and the same odd number of white ones. He lays them at alternate ends, picks up one white splint and drops it in, and continues plaiting it over and under three green splints. Then he turns the mat around and does the same plait on the other side. As the basket proceeds, the next arrangement is over three, under five, and so forth. When he's working, Navasie holds the bundle of yucca splints in his mouth so that both hands are free to construct the basket.

For a simple design, such as the diamond pattern, Navasie starts his basket in the middle; for a more complicated design, he starts on the outside. His convocation basket has an arrowhead design that Navasie said is another way to represent the sun's rays. With his original designs, such as the Hahaey, Navasie has transformed a commonplace, everyday household utensil into a work of art. This adventure into a new design tradition required a certain amount of courage and a great deal of imagination.

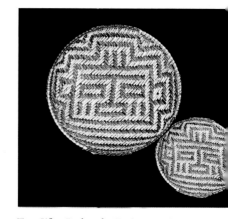

Two Sifter Baskets by Kevin Navasie, 1994. Private Collection. Photograph by Helga Teiwes. These baskets have Hahaey katsina faces and are made with red-dyed yucca leaves. Although katsinas have been depicted in plaited wicker and coiled baskets for a hundred years, Navasie was the first to portray them in a sifter basket.

Plaited Sifter Basket by Kevin Navasie, 1997. Convocation basket. Yucca. Height, 8.5 cm (3 3/8"); diameter, 31 cm (12 1/4"). SAR 1997-8-2.

Although basket making has traditionally been a woman's art among the Hopis, in recent years there have been a few male basket makers. The central diamond design is called the "eye of the basket."

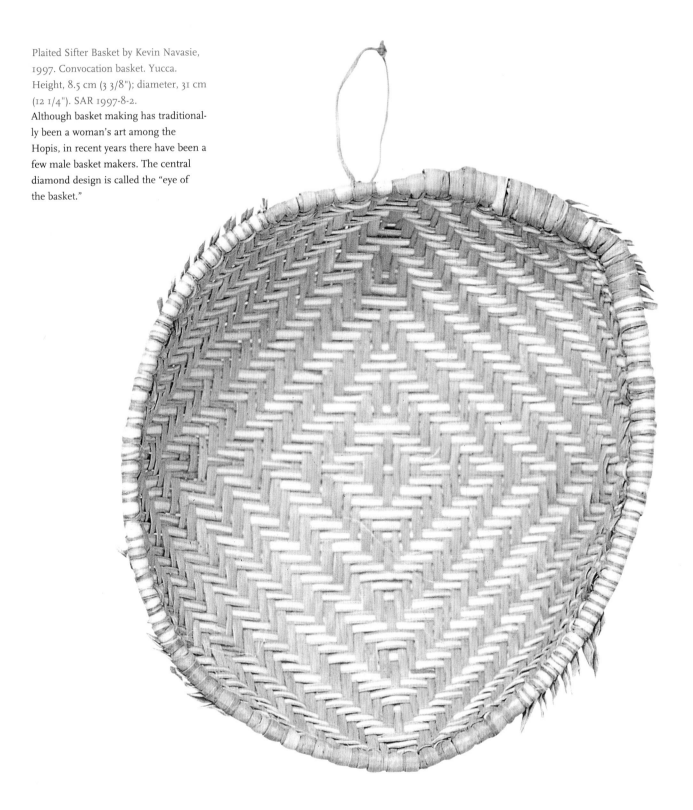

Molly Pesata (Jicarilla Apache)

Molly Pesata is a fourth-generation member of a distinguished family of Jicarilla Apache basket makers. Her great-grandmother, Tanzanita Pesata, "got innovative after the age of seventy." Her grandmother and mother took Molly to gather materials when she was a youngster. She made her first basket when she was ten.

"I went to college," she says, "but then I decided I wanted to spend time outdoors and make my own rules, so basket making seemed like a good idea. I like to make the old kind of water jar. With my people, only the inside of the basket is coated with piñon pitch to make it watertight. The horsehair handles are woven in to help carry it. The only thing that is not traditional about my baskets is the awl I buy from Tandy's."

Pesata's convocation basket is a perfect replica of "the old kind of water jar." It is coiled with sumac splints on a five-sumac-rod foundation. Although she did not have time to coat the inside with piñon pitch, she plans to do so at some future time. Unlike the Navajo version, which has pitch coating on both surfaces, the typical Jicarilla method is to coat the inside only. The braided horsehair handles are stuck in with an awl and then stitched over. Pesata uses leather latigos and decorative vertical lines of double-coiled overstitching, also characteristic features of classic Jicarilla water baskets. According to Joyce Herold, these ascending stitches "are equivalent to a spirit line on a patterned basket"; the spirit line, in turn, "is present in the Creation Story...for it is equivalent to the Emergence sun ladder." Water jars that contain the spirit line tend to stay within the Jicarilla community; those jars that are for sale do not typically have this feature. Thus a water jar made for Jicarilla use contains an esoteric symbolism that transcends its utilitarian role. In addition to lacking the vertical overstitches, many Jicarilla water baskets produced for the marketplace are rubbed with kaolin clay to make them an appealing white color.

Pesata prefers to use sumac because of its "nice white color," although she also will use willow on occasion. She collects her material from late October to the end of November, and again in the spring. She uses new shoots for her starts and two-year-old osiers for foundation rods; the older sticks are stronger and better for splitting. Her basic tool kit consists of a Tandy's awl to make an opening for the coil, pruning shears to collect

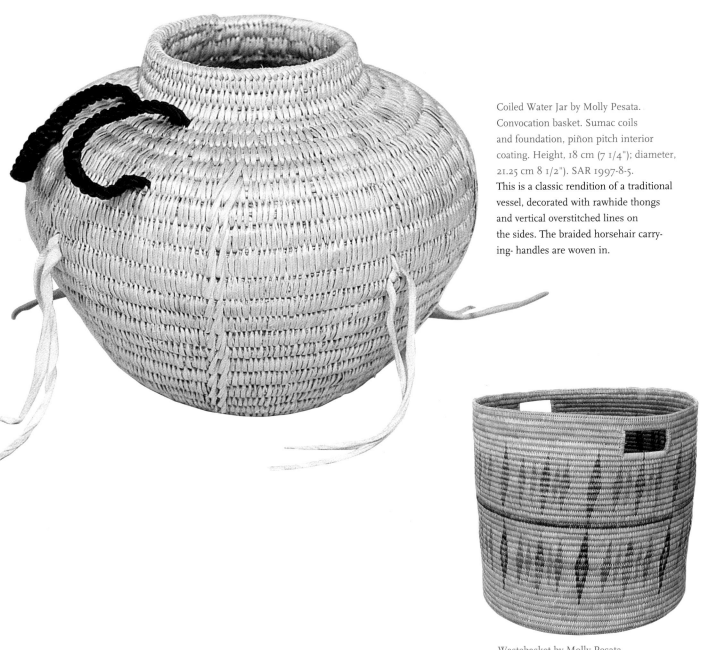

Coiled Water Jar by Molly Pesata.
Convocation basket. Sumac coils
and foundation, piñon pitch interior
coating. Height, 18 cm (7 1/4"); diameter,
21.25 cm 8 1/2"). SAR 1997-8-5.
This is a classic rendition of a traditional
vessel, decorated with rawhide thongs
and vertical overstitched lines on
the sides. The braided horsehair carry-
ing- handles are woven in.

Wastebasket by Molly Pesata.
Photo by Bruce Hucko.

material, and a small pruner to smooth the nonwork surface. She does not waste anything.

Pesata's mother, Lydia Pesata, is a basket maker who is particularly well known for her experiments with vegetal dyes. Like other Jicarilla basket makers, Lydia formerly used commercial dyes because they were quicker and easier, but she thought it would be interesting to try plant dyes. She spent a long time researching them, a difficult task because no one remembered what plants to use. She finally found a woman who remembered a few of the plants, but it took Pesata another five years of experimenting before she achieved satisfactory results (see page 18).

Lydia has taught Molly how to make yellow dyes from Indian tea or the root of the Oregon grape; black dye from sumac shavings boiled in a coffee can with rusty nails; a maroon-red dye from choke-cherries; and a soft orange dye from ground lichen. The task of gathering and processing the dye plants adds considerable time and work to the already labor-intensive basket making process, but the Pesata family believes that the results are well worth the effort. The attractive, subtle palette obtained from vegetal dying makes the Pesata family's baskets distinct from the baskets of most other Jicarilla weavers, who use bright-colored aniline dyes.

Molly Pesata lives in the Jicarilla community of Dulce with her husband and children. She leads a busy life and so can only make baskets as time permits. Her commitment to the "old ways" is partly a result of her mother's teaching that stressed the use of all traditional materials, tools, and methods. Mother and daughter have a close rapport and an obvious enjoyment in making baskets together. The ethnobotanical knowledge that Molly Pesata acquired in order to learn about plant dyes was a significant accomplishment in its own right. In addition to taking copious notes on the preparing and processing of dyes, she spent many hours in the field with her mother to gain first-hand experience in identifying and gathering the plants.

In many ways Pesata is a modern woman, college educated, sophisticated in the ways of the Anglo world, and comfortable in almost any setting. In other ways, she is a vital link in the chain of Jicarilla tradition. She is keenly aware of the connection between basket making and Jicarilla cultural values, and is firmly committed to passing along her knowledge to others.

Coiled Tray and Small Jar by Molly Pesata. Photo by Bruce Hucko.

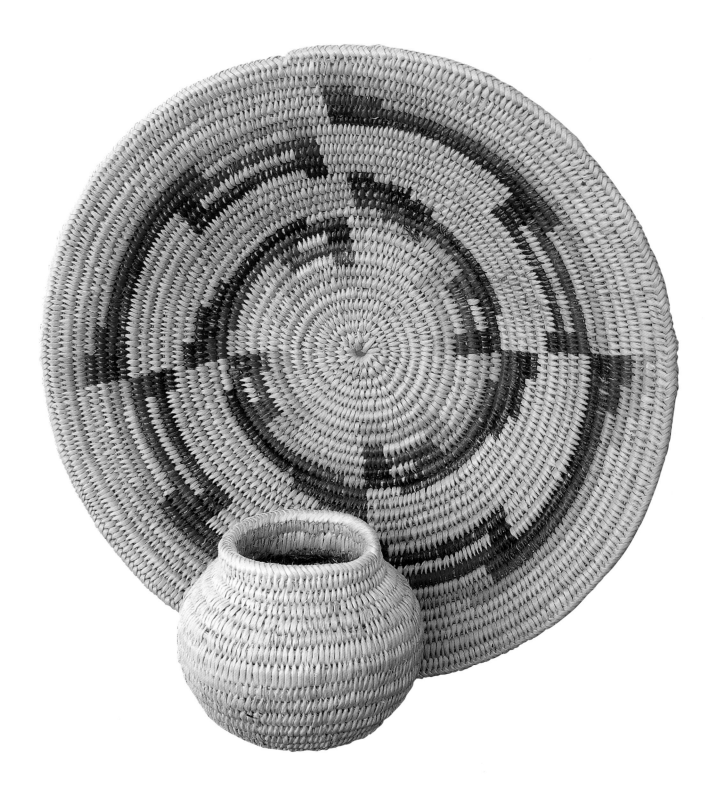

Everyone agreed that obtaining raw materials is the most serious challenge confronting basket makers today.

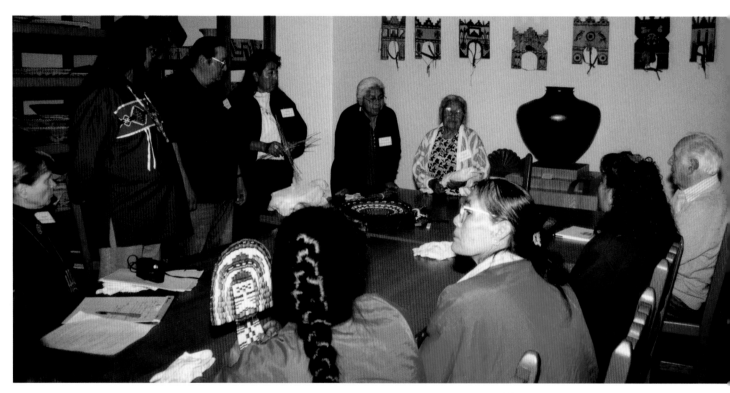

Remalda Lomayestewa (center left) and
Abigail Kaursgowva (center right) talking to the
group during the 1997 Contemporary Indian Artists
gathering at the Indian Arts Research Center
of the School of American Research.

The Gathering

Indian Basketry Artists of the Southwest

When Abigail Kaursgowva commented, "I find it very interesting that all these Indians here are all making baskets, and all the baskets are all different," she was articulating one objective of the convocation: to provide a forum for the cross-fertilization of ideas. Although the baskets were "all different," the basket makers had much in common: a devotion to their art, a willingness to share knowledge, and an enjoyment of each other's company.

Each artist had been commissioned to create a basket for the collections of the Indian Arts Research Center. These newly created baskets, along with historic baskets from the IARC collections, provided a catalyst for lively discourse. It was increasingly evident throughout the convocation that the basket makers could not talk about their work without talking about the raw materials. It was a subject that preoccupied every one of them. Conversation about baskets, materials, and a wide range of other topics continued during meals and a variety of ancillary social activities.

Two issues of common concern became apparent in the course of the week. Everyone agreed that obtaining raw materials is the most serious challenge confronting basket makers today. Highway construction, loss of habitat, encroaching subdivisions, and capricious weather patterns have all contributed to the decline of plant species on Indian lands. The basket makers find it necessary to travel farther afield to gather materials, and in some instances are required to pay a fee to do so on private lands. This adds to the time and cost of producing a basket. Some have tried growing their materials at home, with limited success, except for a few flourishing martynia gardens. In general, tribal councils are neither interested in nor supportive of basket makers' problems.

There also was consensus that marketing and pricing strategies pose an ongoing dilemma. Some basket makers who participate in the Santa Fe Indian Market, Heard Museum Indian Fair, and other prestigious events that provide optimal marketing opportunities are uncertain how to price their work. Kevin Navasie suggested, "As you work, you give yourself a pay raise." Rikki Francisco remarked that

people always ask her, "Are you famous? Did you win a ribbon?" She finds such questions intimidating, and continues to struggle with how much to charge. "My work is me," she said "and this makes it harder to figure out. How can I put a price on me?" Remalda Lomayestewa confessed that she finds "selling around" embarrassing. She had been represented by a gallery in Santa Fe, but unfortunately the owner died, and she currently does not have a place to sell her work.

Annie Antone was charging one hundred dollars per inch until she realized that this did not take into account all the hours she spent collecting and processing materials. In addition, she had a hard time selling her work because her designs were so different. A trader bought quite a bit of her work for a time; now Antone enters shows, takes orders from collectors, and sells to the gift shop of the museum where she works.

Some basket makers establish good working relationships with traders, dealers, and/or galleries. Others said they are reluctant to rely on commercial outlets because "they don't pay enough." Abigail Kaursgowva would rather sell to "white people who come around the village wanting to buy baskets." Molly Pesata does not sell to her tribe's arts and crafts shop because she can make more selling to collectors. "Having a famous mother helps," she added. Sally Black and her sister Agnes sell to tourists who visit their *hooghan* near Monument Valley, but they also sell to local traders. Mary Holiday Black has become so well known that "people come in big cars to take me out to dinner before they buy my baskets." (Many of the convocation participants mentioned that they were honored to be in the company of such a famous basket maker!)

When asked where basket making would be ten years from now, Lorraine Black joked, "There might be flying saucer baskets." She also said, "Car makers come up with new models every year, and so will we." Mary Holiday Black said she hoped that the young Navajo basket makers she is teaching now will be doing really well and have many new ideas. Kevin Navasie remarked that he has ten godchildren. "They

When asked where basket making would be ten years from now, Lorraine Black joked, "There might be flying saucer baskets.... Car makers come up with new models every year, and so will we."

Basket makers are aware that they are a bridge to the past. They also are aware that they are the links to the future.

were given to me to teach because their parents like my values." He added, "The elderlies who are still going on will give us strength."

Joseph Gutierrez is teaching all aspects of Pueblo culture including basket making, fulfilling a dream and his promise to his teacher to "keep it [basket making] up." He said, "When my students catch on real quick, it makes me feel good." He added, "This meeting makes me happy, and I appreciate the chance to meet with other basket makers." Remalda Lomayestewa echoed his sentiments when she commented, "I want to thank everyone. It is very helpful to meet others who are doing this and sharing problems." After the final dinner, Lomayestewa again thanked her colleagues and remarked that the convocation had been "a good encouragement." Then she picked up a drum that was resting on the mantle of the fireplace and sang a Hopi farewell song. There was not a dry eye in the house.

When the convocation participants spoke about their work, they were not simply discussing baskets; they also were speaking about their lives. Their conversations touched on how baskets shape their aspirations, their views of the world, their emotional health, and their economic well-being. Basket makers are aware that they are a bridge to the past. They also are aware that they are the links to the future.

*"The 'elderlies' say that the outer side of
the basket is the universe and the inside keeps
us all together."*
—Kevin Navasie, First Mesa Hopi-Tewa

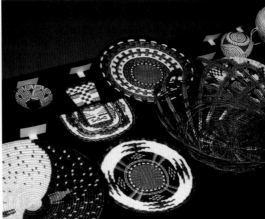

Left to right: Andrew Hunter Whiteford, Lorraine Black,
Mary Holiday Black, and Sally Black.

Rikki Francisco

"I learned to make baskets when I was nine by carefully watching my mother. I like making baskets. I like to see how the designs I think about come out."
—*Sally Black*

Abigail Kaursgowva (left) and Rikki Francisco.

Joseph Gutierrez

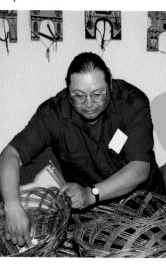

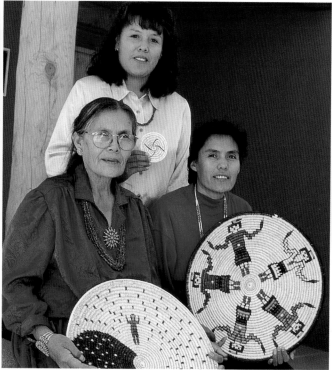

"I find it very interesting that all these Indians here are all making baskets and they are all different. I like being here and talking to these other basket makers."
—*Abigail Kaursgowva*

Left to right: Mary Holiday Black, Lorraine Black, and Sally Black.

*"I want to thank everyone. It is very helpful
to meet others who are doing this (basket making) and
sharing problems. The convocation has been a
good encouragement."*
—*Remalda Lomayestewa*

Remalda Lomayestewa

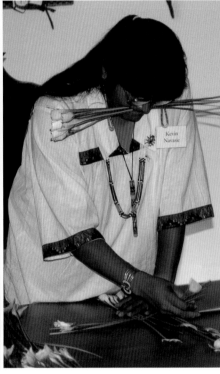

Susan Brown McGreevy
and Andrew Hunter
Whiteford.

Annie Antone

Kevin Navasie

*"I am teaching young people everything about
Pueblo culture, especially basket making. This convocation
is making me very happy and I appreciate the chance
to meet with other basket makers."*
—Joseph Gutierrez

Molly Pesata

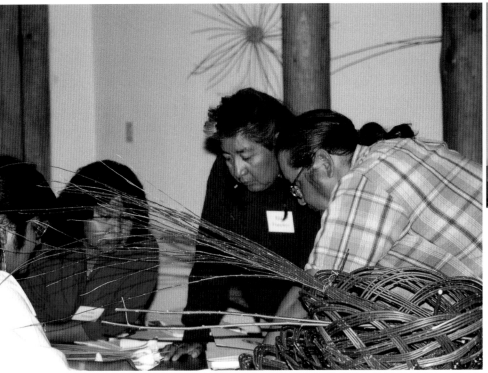

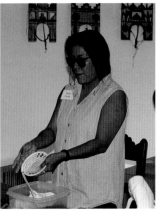

*"I went to college, but then I decided I wanted to
spend time outdoors and make my own rules, so basket
making seemed like a good idea... The only thing
that is not traditional about my baskets is the awl I
buy from Tandy's"*
—Molly Pesata

Joseph Gutierrez talking about his materials to Remalda Lomayestewa (left),
Rikki Francisco, and Abigail Kaursgowva.

Suggestions for Further Reading

Basso, Keith H.
1996 Wisdom Sits in Places: Notes on a Western Apache Landscape.
 In Senses of Place, Keith H. Basso and Steven Feld, eds., pp. 53–90. Santa Fe:
 School of American Research Press.

Dalrymple, Larry
2000 *Indian Basket Makers of the Southwest: The Living Art and Fine Tradition.*
 Foreword by Susan Brown McGreevy. Santa Fe: Museum of New Mexico Press.

Dittemore, Diane D., and Nancy Odegaard
1998 Eccentric Marks on Western Apache Coiled Basketry.
 American Indian Art 23(2):34–43.

Ellis, Florence Hawley, and Mary Walpole
1959 Possible Pueblo, Navajo, and Jicarilla Apache Basketry Relationships.
 El Palacio 66(6):181–98.

Herold, Joyce
1999 Showing the Sun: Mythological-Ceremonial Foundations of Jicarilla Apache
 Basketry. *American Indian Art* 24(3):66–79.

Matthews, Washington
1894 The Basket Drum. *American Anthropologist*, o.s., 7:202–8.
1902 The Night Chant: A Navaho Ceremony. *Memoirs of the American Museum of
 Natural History*, Anthropology, vol. 6. New York: American Museum of
 Natural History.

Mauldin, Barbara
1983 *Traditions in Transition: Contemporary Basket Weaving of the Southwestern
 Indians.* Santa Fe: Museum of New Mexico Press.

McGreevy, Susan Brown
1986 Translating Tradition: Contemporary Basketry Arts. In *Translating Tradition:
 Basketry Arts of the San Juan Paiutes,* Susan Brown McGreevy and Andrew
 Hunter Whiteford, eds., pp. 25–31. Santa Fe: Wheelwright Museum of
 the American Indian.
1989 What Makes Sally Weave? Survival and Innovation in Navajo Basketry Trays.
 American Indian Art 14(3):39–45.

1996 The Storytellers: Contemporary Navajo Basket Makers. In *Willow Stories: Utah Navajo Baskets,* Carol A. Edison, ed., pp. 22–29. Salt Lake City: Utah Arts Council.

1997 Matthews' Study of Navajo Arts. In *Washington Matthews: Studies of Navajo Culture, 1880–1894,* Katherine Spencer Halpern and Susan Brown McGreevy, eds., pp. 16–27. Albuquerque: University of New Mexico Press.

1999 Embellishing the Spiral: Design Development in Navajo Baskets. *American Indian Art* 24(3):44–53.

Robinson, Bert
1954 *The Basket Makers of Arizona.* Albuquerque: University of New Mexico Press.

Tanner, Clara Lee
1983 *Indian Baskets of the Southwest.* Tucson: University of Arizona Press.

Teiwes, Helga
1996 *Hopi Basket Weaving: Artistry in Natural Fibers.* Tucson: University of Arizona Press.

Wheat, Joe Ben
1981 An Early Navajo Weaving. *Plateau* 52(4):3.

Whiteford, Andrew Hunter
1988 *Southwestern Indian Baskets: Their History and Their Makers.* Santa Fe: School of American Research Press.

Acknowledgments

In expressing my appreciation to those who played major roles in making this book possible, my first thanks must go to the ten talented basket makers who participated in the School of American Research Contemporary Indian Artists convocation. Their expertise made the gathering lively, stimulating, and enjoyable. Much of the text of this book is based on the information they provided during the course of the week.

My heartfelt appreciation goes to my colleague and friend Andrew Hunter (Bud) Whiteford, widely recognized as the leading authority on Southwestern Indian baskets. His book *Southwestern Indian Baskets: Their History and Their Makers,* based on the collections of the Indian Arts Research Center, is a vital contribution to the literature of Native American art studies. Initially my associate on this project, Bud attended the convocation, where his trenchant comments, intelligent questions, and gentle wit illuminated the proceedings. In an ideal world he would have co-authored this publication; unfortunately, ill health prevented him from doing so. I have missed his wise counsel, analytical mind, and quiet affection. All I have learned from Bud has guided my path. I hope that he approves the results.

My thanks go also to Duane Anderson and the staff of the IARC. The convocations were Duane's brainchild, and his creative stewardship has been indispensable. The successful implementation of each gathering was the direct result of the time, efforts, and organizational skills of the IARC staff. They deserve sincere congratulations and fervent gratitude.

It was a pleasure to work with Joan O'Donnell, then director of the School of American Research Press, and Jo Ann Baldinger, copy editor. I am grateful for their expertise. I also must thank Douglas W. Schwartz, president of the school, for his enthusiastic endorsement of the series. On behalf of the basket makers, additional thanks go to Nancy Owen Lewis and the Seminar House staff for making their stay so comfortable; kudos as well to Sarah Wimett and her assistants for providing the delicious meals. The convocation participants vigorously applauded the cooks.

There is no doubt that everyone who participated in the convocation was enriched by new knowledge and nourished by fresh insights. This was a memorable event by any and every measure.

—Susan Brown McGreevy

Picture Credits

All photographs of the participating artists and the IARC gathering are by Mark Nohl, unless otherwise noted below. Photographs of all items from the SAR/IARC collections are by Addison Doty.

Abbreviations

ASM Arizona State Museum, Tucson

MNM Museum of New Mexico Photographic Archives, Santa Fe

SAR School of American Research, Santa Fe

SWM The Southwest Museum, Los Angeles

Chapter 1

12 top: Courtesy of the Museum of New Mexico, MNM neg. no. 21820; **14 top:** Courtesy of the Museum of New Mexico, MNM neg. no. 68730; **14 bottom:** Courtesy of the Museum of New Mexico, MNM neg. no. 106876; **17:** All photos courtesy of the Utah Arts Council; **18:** All photos courtesy of Lydia Pesata; **19:** Drawings from *Traditions in Transition* by Barbara Mauldin, pp. 22 and 23, courtesy of the Museum of New Mexico Press; **20 top:** Courtesy of the Museum of New Mexico, MNM neg. no. 102153; **20 bottom:** Courtesy of the Museum of New Mexico, MNM neg. no. 5018-10-1; **21 right:** Courtesy of the Southwest Museum, Los Angeles, photo no. 22828; **21 top left:** drawing from *Traditions in Transition* by Barbara Mauldin, p. 21, courtesy of the Museum of New Mexico Press; **22:** photo from *Traditions in Transition* by Barbara Mauldin, p. 19, courtesy of the Museum of New Mexico Press; **23 top:** drawing from *Southwestern Indian Baskets* by Andrew Hunter Whiteford, p. 121, © 1988 SAR; **23 center:** drawing from *Southwestern Indian Baskets* by Andrew Hunter Whiteford, p. 38, © 1988 SAR; **26:** Courtesy of the Museum of New Mexico, MNM neg. no. 27982; **32:** Courtesy of the National Anthropological Archives, Smithsonian Institution, photo no. 55,621; **35:** © Susan Brown McGreevy; **38:** Courtesy of the Southwest Museum, Los Angeles, photo no. 20800; **41:** Courtesy of the Southwest Museum, Los Angeles, photo no. 24116; **42:** Courtesy of the Museum of New Mexico, MNM neg. no. 98593.

Chapter 2

71: Courtesy of the Arizona State Museum, University of Arizona, ASM neg. no. 86349; **75:** Courtesy of the Arizona State Museum, University of Arizona, ASM neg. no. 86164; **78:** Courtesy of Helga Teiwes; **81 right, 83:** Courtesy of Bruce Hucko.

Chapter 3

All photos by Mark Nohl and the staff of the Indian Arts Research Center, © SAR.